Side by Side

New Poems Inspired by Art from Around the World

EDITED BY JAN GREENBERG

Abrams Books for Young Readers
New York

*To Howard Reeves, who, long ago, was intrigued
by my idea and encouraged me to pursue it.*

Acknowledgments

With grateful thanks to all my helping hands: Lynne Greenberg, who shared two great books on ekphrastic poetry: Murray Krieger's *The Illusion of the Natural Sign* and John Hollander's *The Gazer's Spirit: Poems Speaking to Silent Works of Art*; Jeanne Greenberg Rohatyn, who introduced me to the artist Shahzia Sikander; Ben Avram, Lilly Avram, and Leah Higgins, my young readers and critics; Phil Sadler, guru of the Children's Literature Festival in Warrensburg, Missouri, and his granddaughter, Cheryl Klein, editor at Arthur A. Levine Books, who led me to Susan Harris, editor at Words Without Borders, an amazing online resource for those interested in literary translations; Margaret Sayers Peden, who shared her contacts of translators/friends and led me to ALTA, the American Literary Translators Association; PEN American Center; the poet and writer Dana Gioia, chairman of the NEA, for taking time to talk about the project; Marlene Birkman, associate professor at Webster University, for her always helpful editorial advice; Robin Clark, associate curator of contemporary art at the St. Louis Art Museum; Heidi Zuckerman Jacobson, director and chief curator of the Aspen Art Museum, who led me to Ernesto Neto; the poet and anthologist Naomi Shihab Nye, who led me to Assef Al-Jundi; Gerald Early, Merle Kling, professor of modern languages, Rebecca Copeland, associate professor of Japanese language and literature, and Robert D. Lamberton, professor and chair of the Department of Classics at Washington University in St. Louis; Gordon Bronitsky, who led me to Nanzebah Nora Yazzie; George Nicholson, my agent and friend, who told me about IBBY, the International Board on Books for Young People; Bob Sessions of Penguin Australia; Bruce Bunting at World Wildlife Fund and Pam Ebsworth, who led me to Karma Ura; Dr. Lee Sang-Wha, the wife of the poet Ko Un, for her help with the National Museum in Korea; Rabbi Amy Feder for her work on the Hebrew text of "The Corpse"; Josh and Rachel Johnston, computer wizards; Maggie Lehrman, assistant editor at Abrams, for her persistent help with permissions; Vivian Cheng, for taking on the challenge of designing this anthology; Scott Auerbach, associate managing editor; Jason Wells, Abrams Books for Young Readers' skillful and enthusiastic director of marketing and publicity; and Howard Reeves, my unflappable editor, to whom this book is dedicated. And finally to the poets, translators, and artists whose enthusiasm and dedication made this treasure hunt such a rewarding adventure.

Library of Congress Cataloging-in-Publication Data:
Side by side : new poetry inspired by art from around the world / collected by Jan Greenberg.
 p. cm.
 ISBN-13: 978-0-8109-9471-3 (hardcover with jacket)
 1. Children's poetry. 2. Children's poetry—Translations into English. 3. Art—Juvenile poetry. I. Greenberg, Jan, 1942-
 PN6109.7.T74 2008
 808.81'9357—dc22

 2007011973

Introduction and biographies copyright © 2008 Jan Greenberg
Copyright © 2008 Harry N. Abrams, Inc.
See page 85 for poetry and illustration credits.
Book design by Vivian Cheng

Printed and bound in China
10 9 8 7 6 5 4 3 2 1

HNA
harry n. abrams, inc.
a subsidiary of La Martinière Groupe
115 West 18th Street
New York, NY 10011
www.hnabooks.com

Contents

Introduction

Finding poems for this anthology was like going on a treasure hunt, the treasures spread far and wide, from the Americas to the Middle East and Africa, from Europe to Asia and Australia. Some days, after dozens of unanswered e-mails, I felt like Don Quixote tilting at windmills, dreaming the impossible dream. Then a message would pop up on my screen, one clue leading to another, until one day a collection of poetry in many languages, translated into English, and the artworks that inspired these words, came together to form this book. Along the way many people—poets, translators, artists, editors, and curators—lent helping hands, hands that reached across oceans and cultures. For all these helping hands, I am deeply appreciative. They cheered me on and made an improbable quest a reality.

My quest began with an idea—to share with readers in the United States the rich tradition of ekphrasis, poetry inspired by art, written by poets from all over the world. Never mind that I knew very little about contemporary poetry outside America, or that, other than my high school French, I don't speak or read another language. Still, I am a lover of art and poetry, curious about different cultures, and an insatiable traveler. This project gave me a chance to combine my passions. Also I strongly believe that the arts transcend geography and that, in this troubled world, they have the power to unite us, to inspire courage and hope. What these poets share are universal feelings, ones that help us understand and respect one another despite differences in culture and language.

In my previous anthology, *Heart to Heart: New Poems Inspired by Twentieth-Century American Art*, I focused on poems and artworks made in America. For this volume, I was interested in bringing together voices that speak to us from both faraway places and those closer to home. America is a melting pot, a blend of many cultures and backgrounds. The American poets included in this collection grew up in multilingual households. For example, Pat Mora, whose grandparents fled Mexico during that country's Revolution of 1910, was born in El Paso, Texas, but spoke mostly Spanish at home. The poem she has written and the Mexican folk art piece that inspired it draw on her Hispanic roots and the folklore of her childhood. Nanezbah Nora Yazzie, a member of the Navajo Nation, writes poetry both in the language of her ancestors and in English. She says, "As an artist of words and clay, I am

influenced by the land that is surrounded by the four sacred mountains of my people, the Navajo."

All the poets and translators are living, with the exception of Alexander Pushkin, Russia's most famous poet, whose poem inspired by *The Girl with the Pitcher* in Catherine Park was written in 1830. The poets, translators, and artists in this book represent thirty-three countries and six continents. A treasure map is included to mark their homelands. Still there are many places yet to mark, voices yet to hear. I wish time and space had permitted me to include more of them.

Most of the poems gathered here were written or translated especially for this collection. Several poets, such as Karma Ura from Bhutan and Nimah Ismail Nawwab from Saudi Arabia, write in English. A few chose to write in English and translate their poems into their native language. Some poets are also artists, such as Wafaa S. Jdeed from Syria and Lo Ch'ing from China. I encouraged the poets to choose artworks that were representative of their own cultures. To my delight, the artworks represent a mix of ancient, traditional, modern, and contemporary art, allowing readers to connect the past to the present. Each poem, translation, and artwork can be savored side by side.

The conversation between two art forms, along with the complication of the conversation between two languages, offered a challenge to the contributors of this collection. What have the poet and translators done? They have engaged in an act of seeing, determined to occupy the space between the eye and the object and to bridge the mysterious gap between two art forms. They were willing to entangle themselves in the mystery and to cross borders, both of geography and of genres.

When I finally selected the poems and artworks from so many diverse submissions, I spread them out on the floor of my study and wondered how to organize them into a book. The poems whispered, spoke, and shouted; the artworks shimmered, filling the room with the mingling of different languages, subjects, and sensory images. The poems seemed to arrange themselves, falling into four somewhat overlapping categories: Stories, Voices, Expressions, and Impressions.

In Stories, the poet looks at an artwork and imagines a story. Yusuf Eradam's poem expresses the hopes and fears that people from both sides of the world share. He writes, "We are as different as snowflakes, yet still so alike." The artwork that inspired him is an impressionistic

painting of two leaves touching in snow. It is a symbol for him that America and the Middle East someday will come together in peace.

In Voices, the poet enters the canvas and speaks in the voice of the subject depicted there. In a photograph by Lawrence F. Sykes, a young boy runs through the rubble of his Eritrean village in northeast Africa. The boy in Ghirmai Yohannes's poem is the speaker, who, in trying to make up a story, realizes that he "has a story nobody knows . . . I am the story." Anne Provoost gazes at the portrait of a young woman, painted in 1480 by Hans Memling, and imagines that she, like a teenager in any century, is fantasizing about love.

In Expressions, the poet is interested in the transaction that takes place between the viewer and the art object. Each poem is a meditation on the process of looking, asking questions, and interpreting the nature of the artwork. The Korean poet Ko Un contemplates a statue of an ancient, pensive Buddha and asks,

How can you be so still?
Your stillness makes flowers fall.
Arise, storms,
 blow away every last trace of that
 stillness.

In Impressions, the poet identifies the subject of the artwork and describes what he or she sees in the elements of the composition, such as line, shape, texture, and color. Nimah Ismail Nawwab studies an intricate drawing by Shahzia Sikander from Pakistan and identifies the shapes and forms using alliteration.

Mythical and real interweave
fantastical figures,
Spirited unicorns, delicate deer,
flying fleeing flocks, fierce falcons . . .

The French poet James Sacré is fascinated by the color of Matisse's *Woman in Blue.*

When you look at the painting it's as
If the color were drawing it: better
Than what is shown in the painting,
 a sofa-lyre
Red music
Around a blue dress.

Most of the poems were written in languages that you may not understand. Some of them—for example, Arabic, Tigrinya, Chinese, and Japanese—have alphabets very different from our own. Looking at these unfamiliar letters, you might see them as artworks in and of themselves. You might find yourself

matching words and phrases with those in the translation, figuring out words in Korean or Hebrew preserved for us in English. Or you might try your own translation of a poem in a language familiar to you, such as French or Spanish.

In answer to those who may ask, "How much is lost in translation," I would say that, although a translation can never be identical to the original text, at the same time a translated poem from another culture gains a new life, a new sound, a new way of being understood, and a new audience. Translator Lawrence Venuti says, "Translating a foreign poem can be as nerve-racking as it is pleasurable. The translator must literally take it apart, stripping away its sound, rearranging its words, uprooting it from the language and literature that gave it life. I do it with clenched teeth." The goal, he says, is "to write a translation that can stand as a poem in its own right, clearly related to the foreign one." Another translator, Roger Greenwald, writes, "The translator must have an ear, must be able to hear the music of the poem and make music in the target language."

Poetry inspired by art is a form as old as its most famous example, the shield of Achilles, imagined by Homer in the *Iliad*. It even has a Greek name, ekphrasis, or ἔκφρασις. And ekphrastic poetry has fascinated poets for centuries. The poet takes the time to sit and stare at an artwork, to think about what he or she sees and to write it down. It forces the viewer not only into more than taking in the image but also into finding words to express what he or she feels. Art may challenge our minds, but it also touches our souls. Venuti writes, "I can't think of anything more creative than extending the life of a foreign poem. When the poem is based on a painting, the satisfaction is distinctive and doubled: A new perception comes into English, a new comment on an artwork, along with a new poem." I hope you will take the time to sit and stare and write down what you see. If you embark on your own treasure hunt, may it take you, as it has taken me, to many new and uncharted places.

—Jan Greenberg

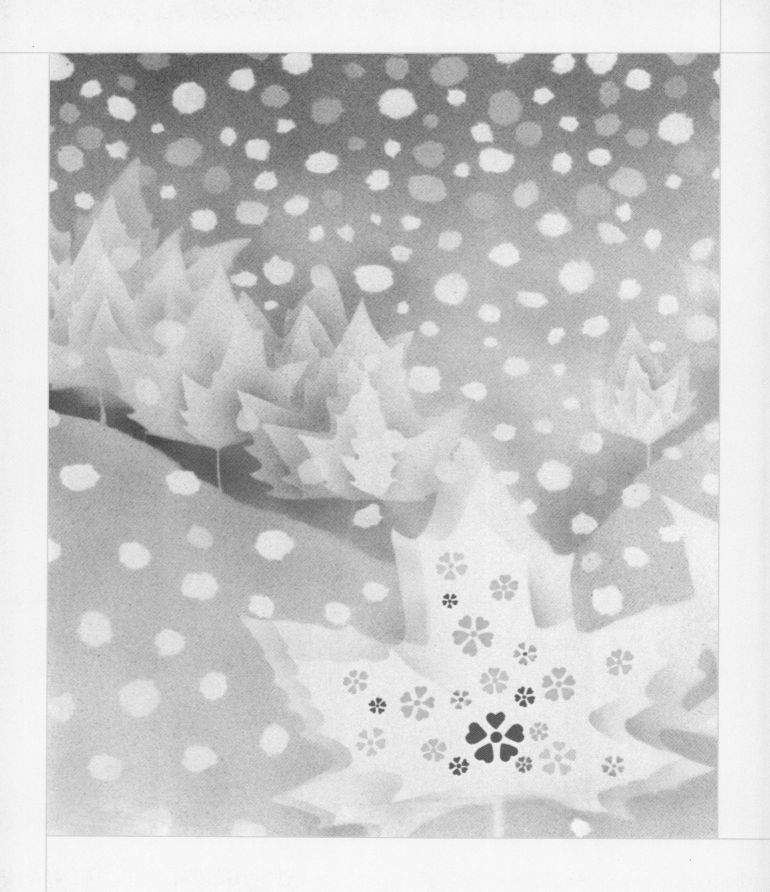

Stories

LOS MÚSICOS MEXICANOS
TRANSLATED INTO SPANISH BY PAT MORA

Al anochecer, abuelo sale, afina su violín,
 y empieza a tocar. Su música recoge
 a los músicos familiares, quienes traen sus guitarras,
trompetas y arpas. Mis hermanas mayores cantan
 en armonía, y mis primos y yo bailamos y corremos
 por entre la música, entre las notas que suben flotando
 por los árboles, a las estrellas.

En noches especiales, todos los músicos del pueblo se reunen—
 hasta las ranas—y todo nuestro pueblo flota
 en el rítimico río de música.

MEXICAN MUSICIANS
BY PAT MORA

At sunset, *abuelo* sits outside, tunes his violin,
 and starts to play. His music gathers
 the family musicians who bring their guitars,
trumpets and harps. While my older sisters sing
 in harmony, my cousins and I dance and run through
 the music, in and out of the notes that float up
 through the trees, into the stars.

On special nights, all the town musicians gather—
 even the frogs—and our whole town floats
 on the rhythmic river of music.

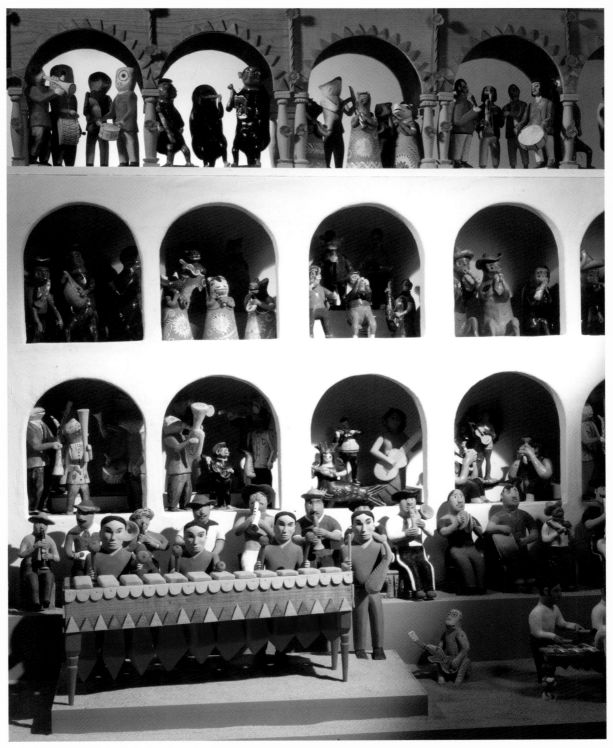

Mexican Musicians. 1978. Ceramic and painted wooden figurines from Mexico

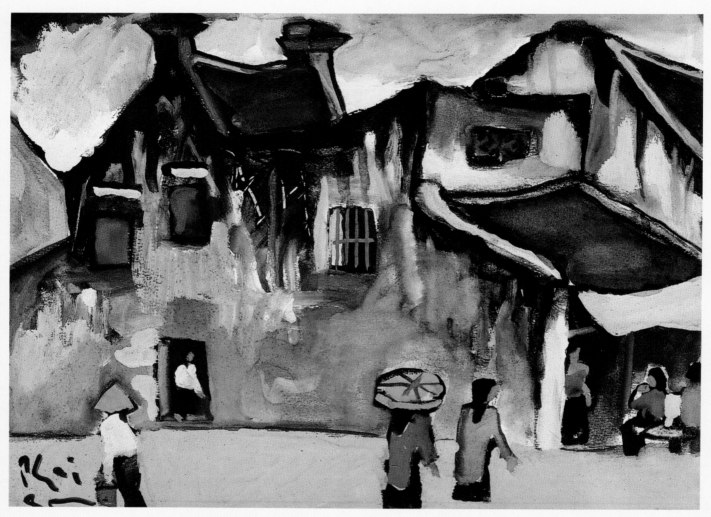

Bùi Xuân Phái. Small Street. 1985. Gouache on paper

MÀU PHỐ PHÁI
BY LAM THI MY DA

Người đi chợ tết mua gà thật
Tôi mua gà đất tuổi thơ tôi
Gà đất bây chừ nằm trong đất
Tiếng gáy còn tươi rộn giữa trời

Bất chợt cầu vồng sà trước mặt
Trăm loài hoa đẹp nói lời mơ
Thấp thoáng trong hoa thiên thần nhỏ
Em gái mắt đen phấp phỏng chờ

Đôi lúc tâm hồn màu Phố Phái
Tĩnh lặng ngói rêu, tĩnh lặng tường
Sớm nay thời tiết như mười bảy
Tở mở lá cành ngơ ngác hương . . .

THE COLOR OF PHAI STREET
TRANSLATED FROM THE VIETNAMESE
BY MARTHA COLLINS AND THUY DINH

At Tet, people buy chickens in the market
I bought a clay rooster when I was a child
Although that earthen rooster lies in the earth
His crowing still echoes brightly in the sky

Suddenly a rainbow sweeps before me
Many beautiful flowers speak dreamy words
In the flowers a small angel keeps appearing
Her dark eyes waiting, full of anticipation

Sometimes I think the soul is the color of Phai Street
Its silent mossy tiles, its silent walls
The morning weather, like being seventeen
The leaves waking up, releasing their strange scent.

Peras

BY MARÍA TERESA ANDRUETTO

Había una rosca cubierta
de azúcar, una mesa con el hule
verde y una frutera de vidrio
(por la loneta de las cortinas, el sol
sacaba tornasolados color de ajenjo),
y había peras. Recuerdo los cabos rotos
y el punto negro que, en una de ellas,
hace el gusano. Sé que las dos teníamos
el pelo corto y unos vestidos
almidonados.

Después algo (quizás el viento)
sonó allá afuera y mi madre dijo
que acababan de pasar
Los Reyes.

The Pears

TRANSLATED FROM THE SPANISH
BY PETER ROBERTSON

I remember the Christmas cake iced in sugar,
the table with its green oilcloth, the glass fruit bowl,
how the dim sun shone through the gauze curtains,
bathing my world in emerald light.
And there, without peer, pear piled on pear.
Some, at their ends, had been nibbled away,
and the one with its black speck, the trail of the worm.
I remember that Yuletide how, clad in starched dresses,
we wore our hair in tresses,
as was the fashion.

And I also recall that sound from outside.
It came to me then like a sigh,
so I thought it was only the wind.
But Mother said,
"The three wise men have just passed by."

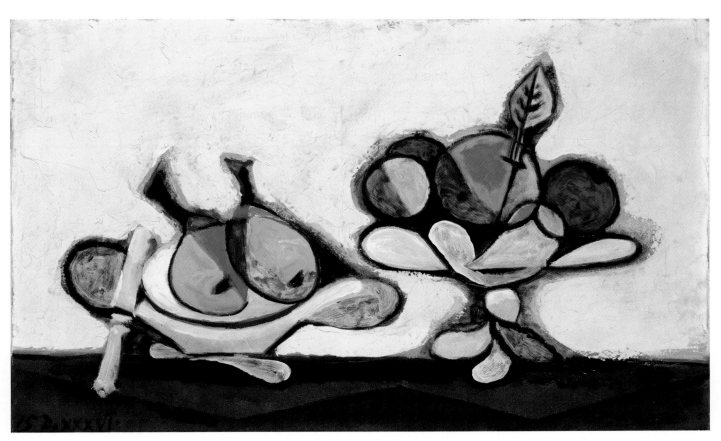

Pablo Picasso. **Dish of Pears**. 1936. Oil on canvas

YAPRAK ELİM SENDE
TRANSLATED INTO TURKISH BY YUSUF ERADAM

Savaş! Bunun için mi sokulmuşuz birbirimize böyle?
Biz kar taneleri gibi farklıyız, ama benzeriz de birbirimize.
Biz mühürüz, karın sildiği. Ama böyle de uzağız işte.
Kar durmaya görsün biraz, durur baharı bekleriz;
Atalarımızın hataları hiç çıkmaz aklımızdan,
Çektiğimiz acılar hiç çıkmaz aklımızdan.
Kar yağsın hele bir Orta Doğu'da,
Biz iki yaprağız ya sokulmuşuz birbirimize,
Kucaklaşıp sevinçle dans etmeden az önce,
Yaprak elim sende, barış olsun diye,
Barış.

TWO LEAVES IN SNOW
BY YUSUF ERADAM

War! Is that why you and I are so close?
We are as different as snowflakes, yet still so alike.
We are the seal the snow withers, yet so far apart.
Knowing this in the lull of snow, we wait for spring;
We do not forget the mistakes of our ancestors,
We do not forget the pain we have suffered.
When it snows in the Middle East,
We will come together, but before we embrace
And dance in joy, we will learn to be
Two leaves touching in snow.
In peace.

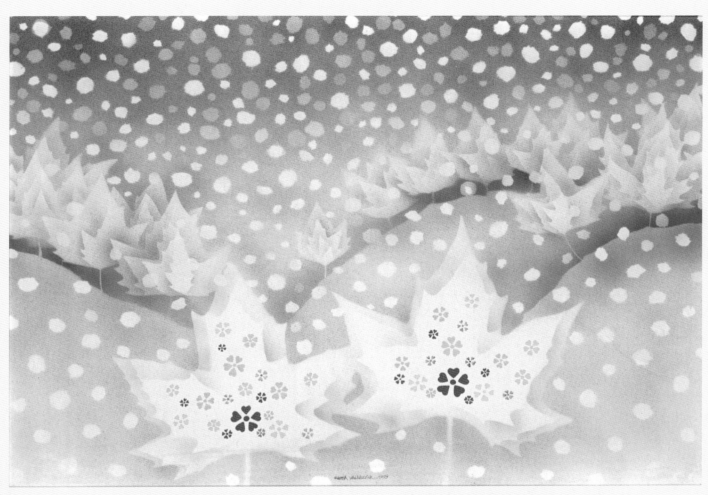

Reha Yalnizcik. **Two Leaves in Snow**. 1993. Acrylic on canvas

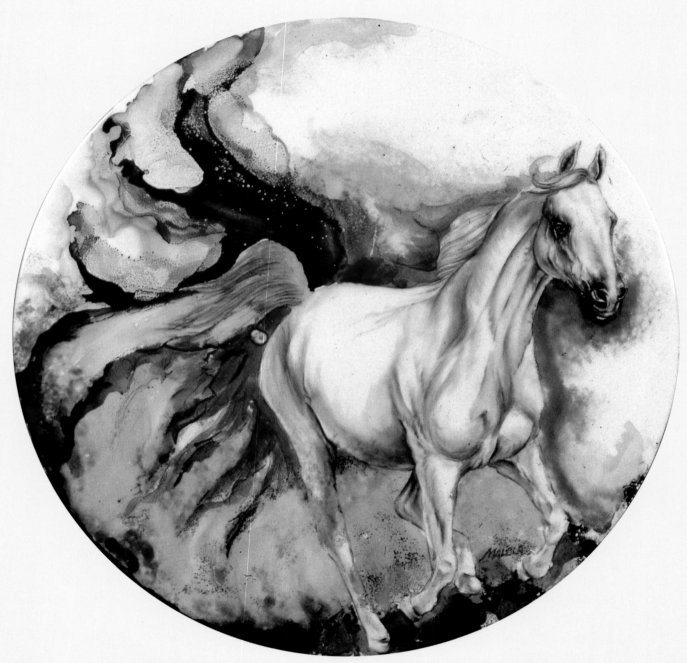

Malola (Maria Gloria Echauri). **Tornado**. 1996. Painting on porcelain disc

GALOPE
BY RENÉE FERRER

Para César Enrique

Bandera de crin al viento,
cascos turban el silencio,
devorando campo y cielo,
se van . . . , se van.

Polvo flotando en la senda
angosta de roja tierra,
como pájaros errantes
se van . . . , se van.

En la verde inmensidad
se diluyen como un sueño
jinete y potro azulejo.

Hacia el caer de la tarde
cuando todo está desierto
se escucha un leve trotar
desde los cerros.

¿Cuántos pensamientos juntos
han compartido a lo lejos
bajo los montes umbríos,
callados, quietos?

De esas tristezas y sueños
Jinete y potro azulejo
solo sabrán el secreto.

GALLOP
TRANSLATED FROM THE SPANISH BY TRACY K. LEWIS

for César Enrique

Mane like a flag in wind,
hooves rock the silence.
Devouring field and sky
they go . . . they go.

Dust hovering in air
above the narrow red-earth path,
like wandering birds
they go . . . they go.

Rider and pony blue
in vastness green
fading like a dream.

Toward the falling of the dusk
when all is vacant and alone
from mountainside and valley
comes the sound of hooves on stone.

Horseman, horse,
what thoughts have shared in distances
of somber, umber,
silent wood?

Who can know nor ever knew
the sadness and the dreams
of horse and rider lost in blue?

DUBBELGÅNGARNA
BY GUNNAR HARDING

När ett par promenerar i en park
och möter ett annat par
som i allt är deras dubbelgångare
är det ett dåligt omen.

Bägge paren stannar upp
och stirrar på varandra.
Det finns inga ord att utväxla.

De som i en park möter sig själva
kan inte gå någon annanstans
än dit varifrån de andra kommer
till resterna av en redan genomlevd kärlek
i en utkyld lägenhet
där hyran inte betalats på månader.

Där ska de med händerna söka efter
dem de en gång var
och lyssna om nätterna
till hur mössen gnager på brev och färgtuber

tills det enda som finns kvar
är ensamheten innan allt tog sin början.

THE DOPPELGANGERS
TRANSLATED FROM THE SWEDISH BY ROGER GREENWALD

When a couple strolls through a park
and encounters another couple
in all respects their doppelgangers
then it's a bad omen.

The two couples stop
and stare at one another.
There are no words to exchange.

Those who meet themselves in a park
have nowhere else to go
but where the others came from,
to the remains of a love already played out
in a chilly apartment
where the rent hasn't been paid in months.

There they will search with their hands
for the people they once were
and listen at night
to the mice gnawing on letters and tubes of paint

until the only thing left
is the loneliness before it all began.

*A doppelganger (from the German for "double-goer") can
mean a double, a person who looks just like someone else, but in
literature and other art forms, the double is often a mysterious
and disturbing figure, a ghostly or dreamlike mirror image of a
living person.*

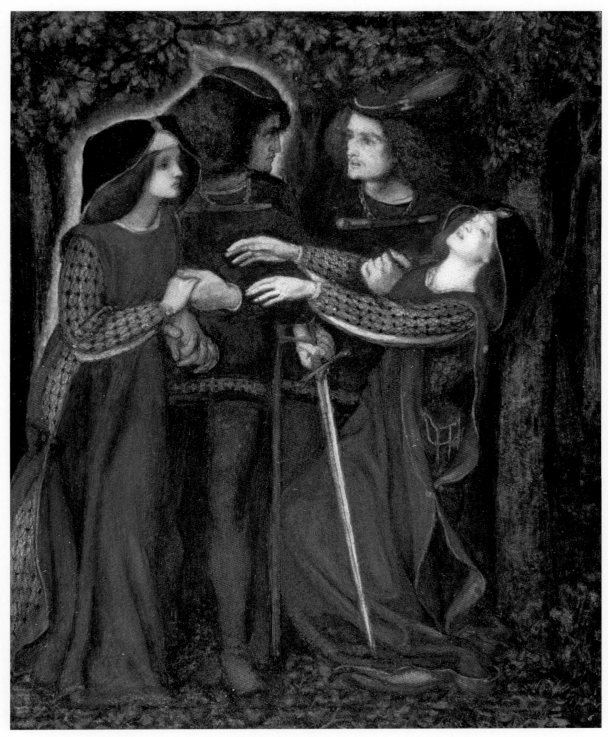

Dante Gabriel Rossetti. **How They Met Themselves.** c. 1850–60. Gouache on paper

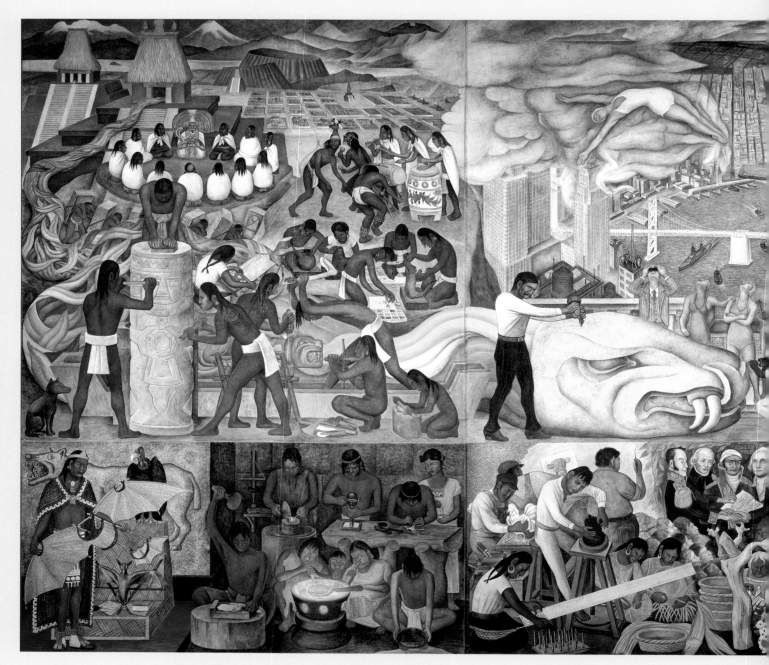

Diego Rivera. Pan American Unity. 1940. Mural on five panels

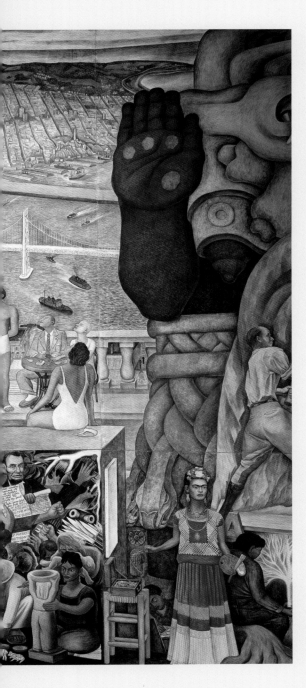

Quetzalcoatl
BY CARMEN T. BERNIER-GRAND

In the beginning the Plumed Serpent
saw that the earth was under water.

Undulating his quetzal feathers,
he flew down from the heavens.
His breath of life divided waters from waters.
Dry land appeared on earth.

On earth, he took the form of a fair-skinned man
with a beard like the rays of the sun.
He invented the books and the sun calendar,
abolished human sacrifices, gave maize to mankind.

Upon his death, he ascended to the heavens.
His heart became the morning star of our dawn.

THE BALLAD OF PEMI TSHEWANG TASHI
An excerpt from a Bhutanese poem
BY KARMA URA

The crests of Phanyulgang are like Tibetan hills;
Tibetan hills and plateaus are reserves of gold.
The foothills of Komathang are like Indian places;
Indian places and plains are reserves of silver.
Up, in the lap of Khujuk mountains
Down, on the neck by Sumthuet bridge
Where Dzongothang has been levelled
Where Thangochoten has been constructed
Where *choten* and *mani*[1] are circumambulated
Where the *mani*, in clockwise direction, is rotated
Where *gayshing*[2] is in profuse blossom
Where the blossoms are offered to gods
Where the tail of the *dzong*[3] ends on cliff

Where the cliff is braced by the river lake
Where the river lake is beautified by turquoises
Where turquoises are offered as *mandala*[4]
Where the *dzong* is painted white
Where red-band[5] is painted vermilion
Where the door frames are painted dark blue
Where the entrance is through a single gateway
Where inside, individuals have their own chambers
Where each chamber has an antechamber.
In the chamber with its balcony to the East
Dwells Aum Wangmo's[6] Angdruk Nima
In the chamber with its balcony to the South
Dwells the head abbot of the abbey.

[1] Both *choten* and *mani* are shrines.
[2] *Gayshing*, an evergreen tree, does not flower. However, there are cotton trees near the *dzong* that give bright red flowers.
[3] *Dzong*, the monastery or abbey.
[4] *Mandala* represents Buddhist cosmic structure. The whole universe, which the *mandala* signifies, is submitted as an offering during ceremonies.
[5] *Kaymaar*, a red band painted below the eaves of the *dzong* to denote that it is a religious structure.
[6] Aum Wangmo is the mother of Chamberlain Angdruk Nima.

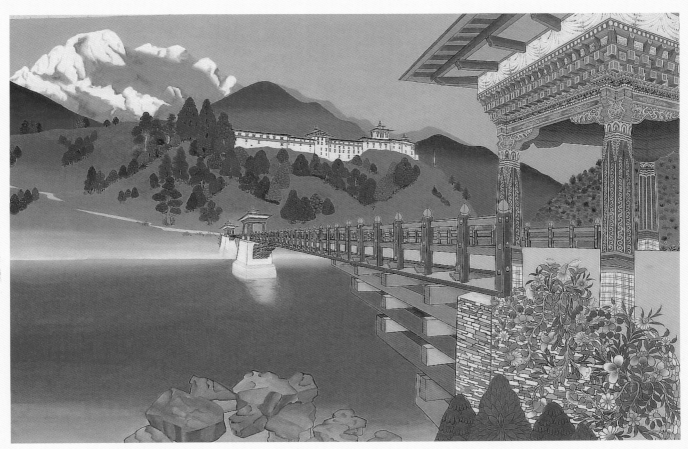

Karma Ura. Wangdue Dzongan. 1994. Painting on lime-coated cloth

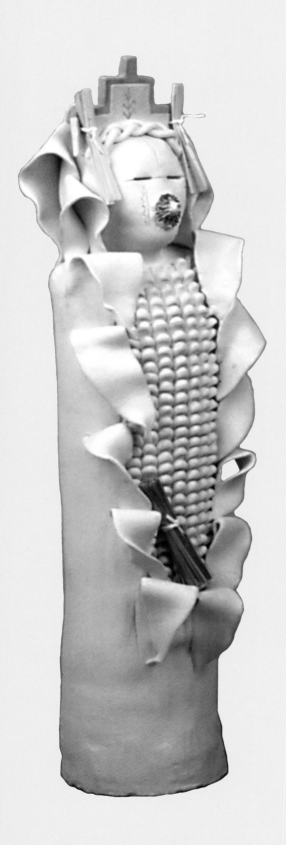

Tká Adí Díín

BY NANEZBAH NORA YAZZIE

abíní goh
shimasani tká adí díín yikéé deyá'
nahaasdzaan bi káá nizhonigo sin do tsodizin adéi doo léél

daan ndee yeh łlaan goh naadą́ą́ k'ididííya'
łla da łlchíí'
łla da łitso
łla da łigai
łla da dootł'izh
nihaasdzaan bi káá nizhonigo sin do tsodizin adéi doo léél

tká adí díín doh tsodizin
nizhonigo ho doo leeł
tka adí díín doh tsodizin
nizhonigo bi káá nashadoo

hozho na haas dłíí
hozho na haas dłíí
hozho na haas dłíí
hozho na haas dłíí

Nanezbah Nora Yazzie. Corn Mother.
2001. White clay embellished with corn husks and deer skins

On the Path of Pollen
Translated from the Navajo
by Nanezbah Nora Yazzie

at dawn
she rises to prepare the gathering of pollen
 basket in hand
 song in heart
like earth, she is born of morning strength
like earth, she is born knowing the purpose she brings to the universe

tall green stalks stretch in rows and rows of a good harvest
each crowned with golden feathers
shooting upwards in reverence to father sky
each bearing the colors of the four directions
 red, yellow, white, and blue

gently she shakes golden feathers
as pollen dance in sprinkles
while she blesses the act with song
in honor of the sacred offering

on the path of pollen she walks
as she sings her prayer into motion
 of morning strength she blesses me
 of purpose on earth she blesses me
 like tall green stalks I walk
 on the path of pollen I walk

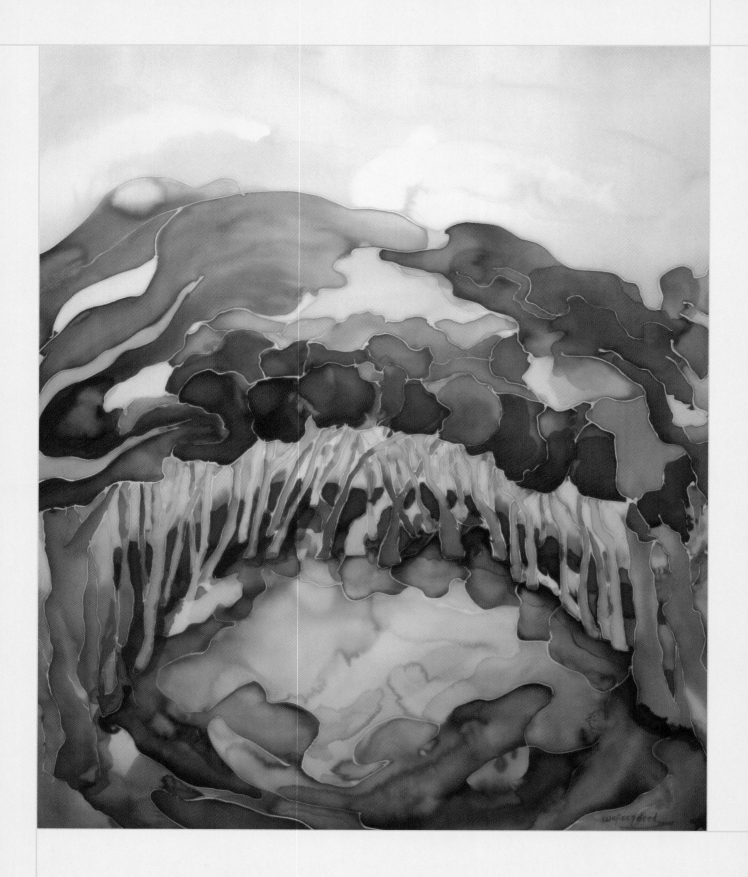

Voices

ጽውጽዋይ ጽሒፈ

BY GHIRMAI YOHANNES

መዓልትን ለይትን ደኺመ
ረሪኻ ዘይድቅስ ጽር ሓላባት ሓዚለ
ተጨኒቸ! ውሻጠ አእምሮይ ሓሊበ፡
ሓሳብ ንሓሳብ አጋጭየ - ቃላት አብ ሽክናይ ሓቚነ፡
ዘዝጽዓየለይ መሪጽ ብልበይ ዛንታ ቀዊደ፡
ብርዐይ ወረቐተይ አዋሃሂደ-ተ-ዋ-ዲ-ደ፡
ትማሊ ሞሽት ተአንቲተ - ጽውጽዋይ ክጽሕፍ ሃቒነ።

ግን'ከ ክንቱዩ ነይሩ ዘየድሊ ድሻም፡
ግዜኻን ሓንጎልካን "ንብላሽ" ምብኻን፡
ከመይሲ!...............
ጽውጽዋይ ምጽሓፍ አይመድለየንን ንዓይ፡
ዋላ አይፈለጥ ምዕራፍ መወዳእታይ፡
እነኹ'ንዶ ባዕለይ ጽብቒቲ ጽውጽዋይ።
ክላ ሉምስ ንዒቐያ - መዚነያ ነብሰይ፡
ጽውጽዋይ ክለኹስ - ጽውጽዋይ ምጽሓፈይ።

WHO NEEDS A STORY?

TRANSLATED FROM THE TIGRINYA
BY CHARLES CANTALUPO
AND GHIRMAI NEGASH

I needed a story
And asked myself all day—
What can I write?
It kept me awake all night—
What do I have to say?

I emptied so many words
And ideas out of my brain
It would have floated away
If not tied to my heart.
Now I needed art.

Paper and pen in hand,
Tomorrow I would start . . .
But wait.
What is this all about?
Do I really need a story?

All this time and hard work—
For what?
I hate myself for thinking this.
I already have a story
That nobody knows and it's great—
I am the story.

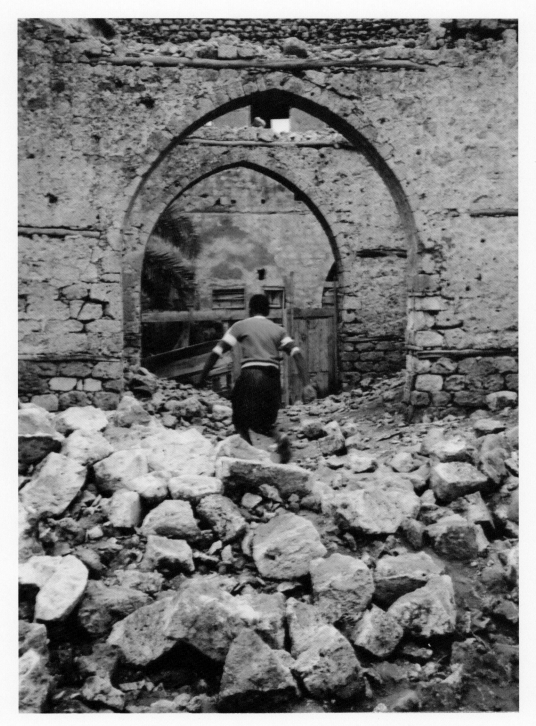

Lawrence F. Sykes. Massawa Moment. 2005. Photograph on paper

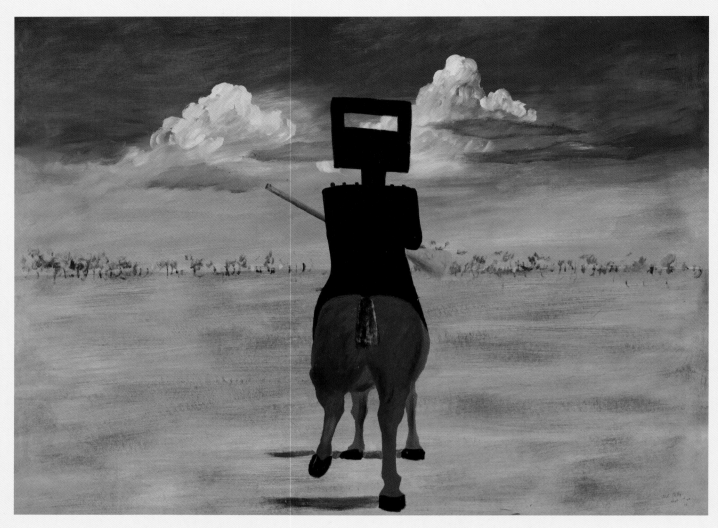

Sidney Nolan. **Ned Kelly**. 1946. Enamel on composition board

NED KELLY
BY LORRAINE MARWOOD

I am stepping out into the open
the trees and hills of my bush cover
ahead, just like the clouds of my dreams.

I am Ned Kelly expert Bushman
Marksman, Horseman, fit and strong
riding for justice, my last stand.

My torso is now armour, blacksmithed
from plough parts, every rivet
an echo of dust, drought and hunger.

I have tried every avenue,
but cattle thief and cruel accusations
have branded my family.

Here then I ride, horse hoof up
striding into Glenrowan
onto the hangman's noose.

But for one ochre sunset, I am
still riding 1878 and beyond
I am legend and ghost, a mirage of justice.

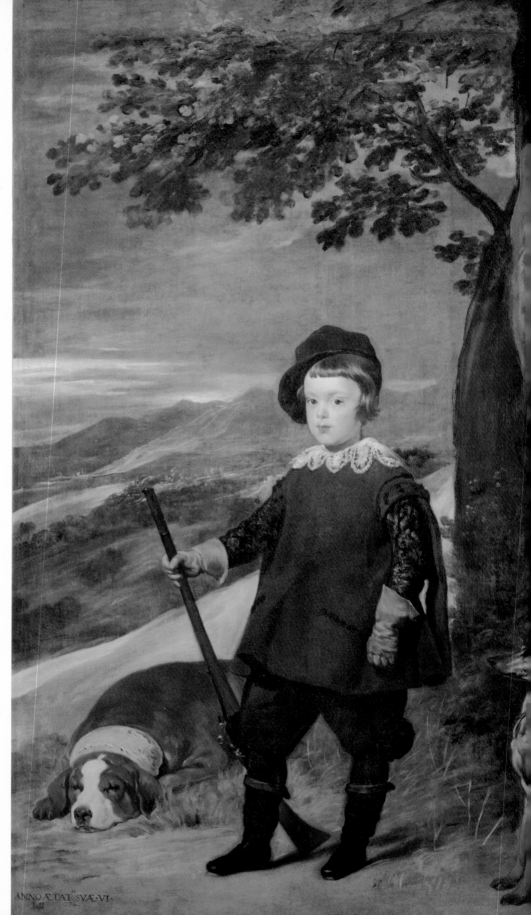

Diego Rodriguez Velázquez.
**Portrait of Prince
Balthasar Carlos de Caza.**
1635–36. Oil on canvas

Retrato del Principe Baltasar Carlos de Caza
by Luis Martínez de Merlo

Cuando sea mayor llevaré una corona de oro y pedrería
y un manto rojo bordeado de armiño, de quince metros por lo menos.

Cuando sea mayor me harán profundas reverencias
interminables filas de duques, de condes, de marqueses, de arzobispos
 de mariscales, de almirantes y de embajadores,
que esperarán que recuerde sus títulos y les dedica una sonrisa,
como hace mi padre conteniendo un real bostezo.

Cuando sea mayor enviaré ejércitos y flotas invencibles,
y los poetas compondrán panegíricos a mis virtudes y a mi valor.

Cuando sea mayor seré yo el Rey de todas las Españas,
y entonces podré enviar a una mazmorra al maestro Velásquez,
que me regaña cada vez que me muevo, con su acento andaluz . . .

-Estese quieto, su Alteza Serenísima,
porque si no nunca podré terminar este retrato.

Sí, a la mazmorra más oscura.

Portrait of Prince Baltasar Carlos de Caza
translated from the Spanish by Lawrence Schimel

When I'm older I'll wear a crown of gold and stones
and a red cape bordered with ermine, at least 15 meters long.

When I'm older they will all bow to me,
the neverending rows of dukes, counts, marqueses, archbishops,
 marshals, admirals, and ambassadors,
who will each hope I recall his title and grant him a smile,
as my father does now, stifling a royal yawn.

When I'm older, I'll command invincible armies and armadas,
and the poets will compose odes to my virtues and my courage.

When I am older, the King of all the Spains will be me,
and then I'll be able to send to a dungeon this Master Velásquez,
who criticizes me with his Andalusian accent every time I move . . .

"Be still, your Most Noble Highness,
because otherwise I'll never be able to finish this portrait."

Yes, to the darkest possible dungeon.

FOREST
BY WAFAA S. JDEED

مبللان بالإنتظار
شتويٌ يأتي دائماً
ترحلُ في إثره النوارسَ
يستفيق اللوزُ على مرارته الأثيرةِ
فاطعم اللقيا مزدانةٌ بالغرائبِ
ثم عددِ العناصر
متسامقين كأجنحة الصنوبر
يشدنا فراغُ الفضاءاتِ
أحرارُ دون ثقل الجسدِ...
، في سكون
منغلقةٌ حولنا ظلالُ الغابهِ الوارفه
أصبحنا كلاً
مفتوحاً على العالم

FOREST
TRANSLATED FROM THE ARABIC
BY ASSEF AL-JUNDI

Drenched with waiting.
He always arrives with winter.
Seagulls follow his trail.
Almonds awaken to their delectable bitterness.

So nourish a union ornamented with rarities,
then count the elements . . .

Reaching out like winged pines,
bareness of spaces tugging on us,
liberated from the body's weight,
in stillness,
shadows of lush forest enclose us.
We become whole
open to the world . . .

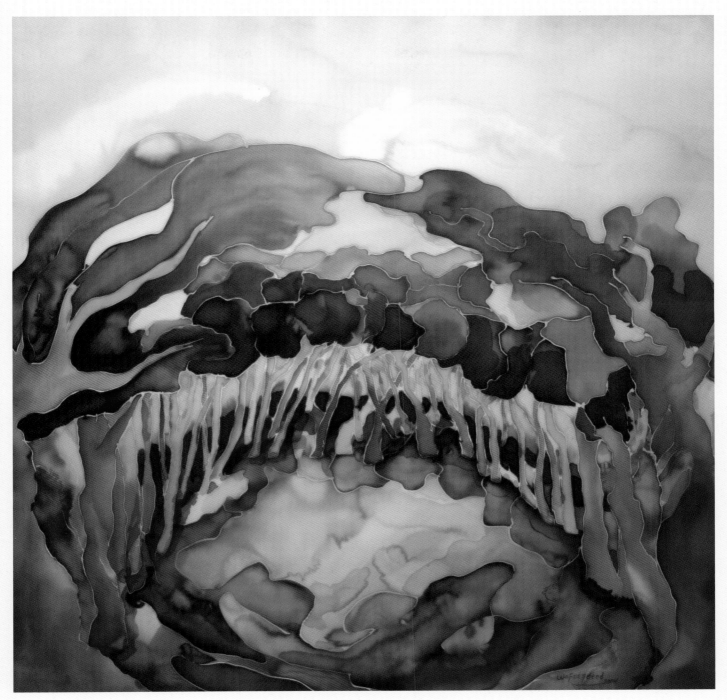

Wafaa S. Jdeed. Forest. 2004. Silk colors on silk

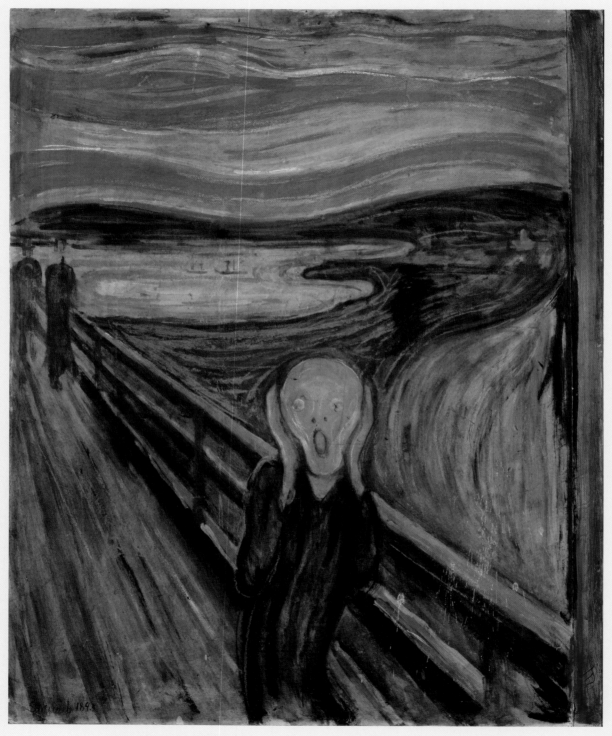

Edvard Munch. The Scream. 1893. Tempera and pastels on cardboard

DER SCHREI
Edvard Munch
BY GÜNTER KUNERT

Der Schrei berühmt und polyglott
Dem Betrachter nahe: kein Mann,
keine Frau, allein
das pure Menschenwesen, Ausdruck
archaischen Entsetzens.
Im Hintergrund indes
schreiten wir Seit an Seit
unbeirrt davon, allerbesten Wissens,
was der Maler
von unserem Charakter hält.

THE SCREAM
Edvard Munch
TRANSLATED FROM THE GERMAN
BY GERALD CHAPPLE

The scream renowned and polyglot
up close to the viewer: not a man,
not a woman, just
pure human essence, an expression
of archaic horror.
Meanwhile we are walking
in the background side by side
undeterred, as far as we could tell,
by the painter's
view of our own character.

הנבלה

BY ROY "CHICKY" ARAD

הָעַיִט קָרֵב אֶל הַנְּבֵלָה
הַבַּז חוֹרֵק עֵינוֹ אֶל הַנְּבֵלָה
יוֹם סַגְרִיר. בְּכָל זֹאת, נָחָשׁ זוֹחֵל עַל גְּחוֹנוֹ אֶל הַפֶּגֶר,
מִלְּשׁוֹנוֹ עוֹלֶה אֵד צָהֹב וְאֶרֶס
הָעַיִט וְהַבַּז צְנוּחִים אֶל הַנְּבֵלָה
רָאשֵׁיהֶם צְמוּדִים זֶה לְזֶה בְּתַחְחָרָה
הָעַיִט נִקֵּר בְּגַחוֹן הַבַּז׀ עוֹף שֶׁל עֹז וְחַיִל נוֹשֵׁר אֱלֵי צִיָּה
צִפּוֹרֶת גְּבוּרָה נִגְלֶלֶת בַּחוֹלָה

הַנָּחָשׁ קָרֵב, כְּבָר יָרִיחַ אֶת הַנְּבֵלָה׃ הֶחָלָקְלַק כֶּעָתִיד, הַדּוּר כַּדֵּעָה
גַּם הַנַּדָּל הַדּוֹהֶה זוֹמֵם מִסֶּלַע אֶל הַנְּבֵלָה
חִוֵּר כַּדַּף׀ רַגְלָיו כְּלַמֶ"ד מְהֻפָּכָה
אַךְ זֶה אֲנִי הָרִאשׁוֹן שֶׁהִגַּעְתִּי אֶל הַנְּבֵלָה
אֲנִי הַנְּבֵלָה

The Corpse

TRANSLATED FROM THE HEBREW
BY ERAN HADAS AND JAN GREENBERG

The hawk approaches the corpse.
The falcon squints his eyes at the corpse.
It a rainy day. Nevertheless, a serpent crawls on its belly towards the carcass dome.
Out of his tongue rises a vapor of yellow and venom.

The hawk and the falcon fall onto the corpse.
Their heads cling in contesting poses. The hawk pokes the falcon's belly.
A brave ladybird lies rolled in the desert sand.

As slippery as the future, as elegant as an opinion,
The serpent comes closer, it can already smell the corpse.
The faded centipede schemes from the rock to the corpse,
As pale as a page! Its legs like an upside down "y"!
I am the first to reach the corpse:
I am the corpse

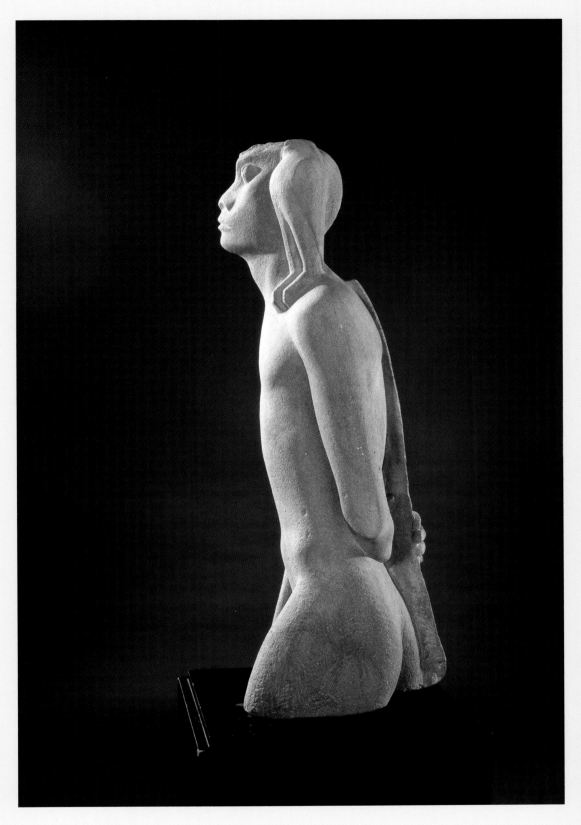

Itzhak Danziger.
Nimrod. 1939.
Nubian sandstone

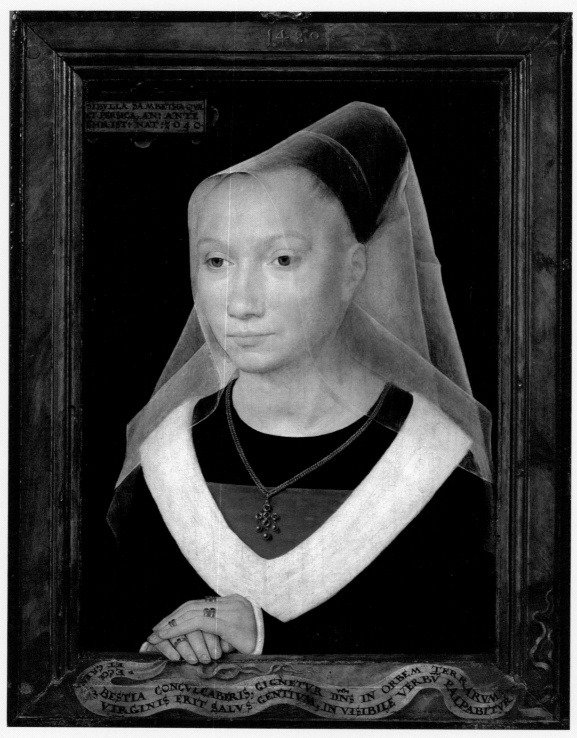

Hans Memling. **Portrait of a Young Woman**. 1480. Oil on oak

Bij Sibylle Sambetha van Memling
BY ANNE PROVOOST

Zittend op een stoel
werk ik aan een kanten kraag voor mijn vader,
als plotseling de jongeman het luik van de vliering openduwt.
Hij werpt zich op de knieën
en zegt dat hij voor mij gekomen is.
'Nooit heb ik een vrouw als u aanschouwd,' zegt hij.
'Uit uw gezicht komt het licht dat ik alleen
in het glasraam van kathedralen heb gezien.'
De klosjes tussen mijn vingers raken in de war.
Ik sla mijn ogen neer en weer op en dan weer neer.
Nog nooit heb ik aan mezelf gedacht als aan een vrouw,
en nog nooit heb ik mezelf aantrekkelijk gevonden.
De jongeman kijkt zo smekend,
zijn lippen trillen zo
en zijn ogen worden zo wazig,
dat ik hem toesta mijn handen aan te raken.

Memling's Sibylle Sambetha
TRANSLATED FROM THE DUTCH
BY JOHN NIEUWENHUIZEN

Seated on my chair
I work on a lace collar for my father,
when the young man thrusts open the hatch.
He falls to his knees
and says it is for me he has come.
"Never have I beheld a woman like you," he says.
"From your face shines the light I have only seen
in the stained glass of cathedrals."
The spools between my fingers become tangled.
I look down and up and then down again.
Never have I thought of myself as a woman,
never seen myself as attractive.
The young man's look is so full of entreaty,
his lips are so trembly,
his eyes so misty,
that I permit him to touch my hands.

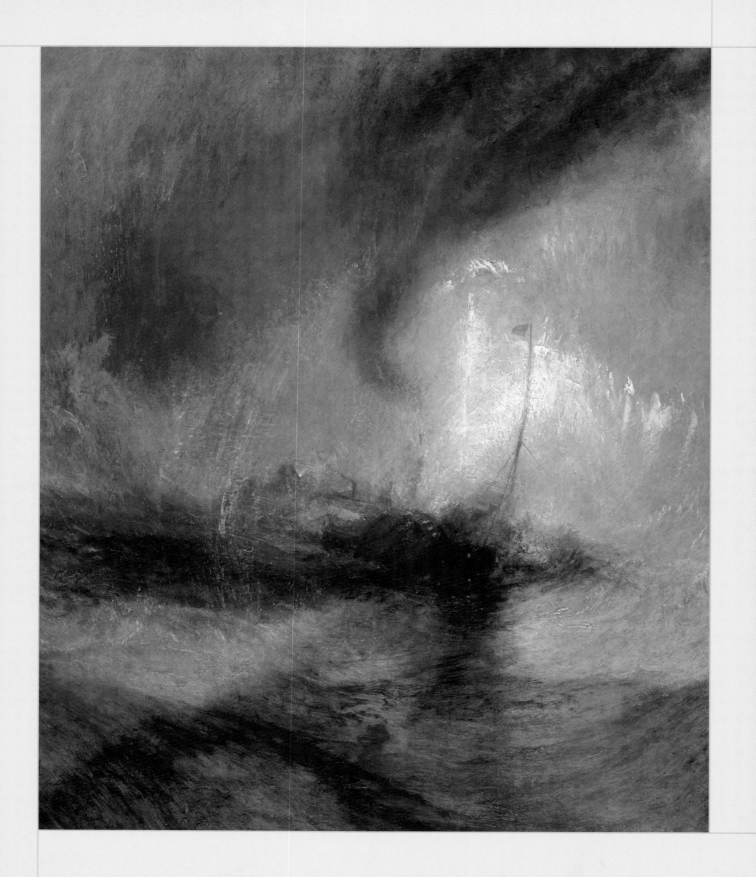

Expressions

Muzeum Sztuk Pięknych w Budapeszcie
by Ryszard Krynicki

Jak tu się znalazłaś,
biedna mumio egipskiej kapłanki,
wystawiona na cudze spojrzenia?
Teraz tutaj są twoje zaświaty.
Sam przez chwilę jestem ich cząstką,
póki patrzę na ciebie.

Innych, jak dotąd, nie ma.
Nie wiadomo, czy będą.

The Museum of Fine Arts in Budapest
translated from the polish by alissa valles

How did you find yourself here,
poor mummy of an Egyptian priestess,
exposed to alien stares?
Now it is here you have your afterlife.
I myself am a part of it for a moment,
while I'm looking at you.

So far there is no other.
No one knows
if there will be.

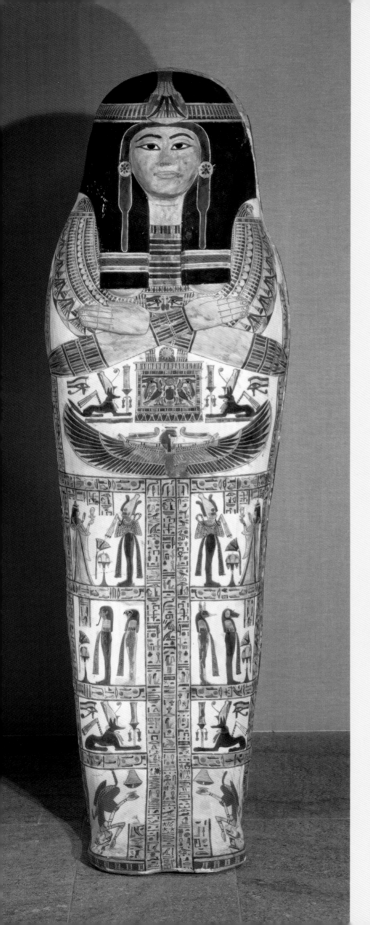

Outer Coffin of Henettawy.
c. 1040–991 BCE. Plastered and painted wood

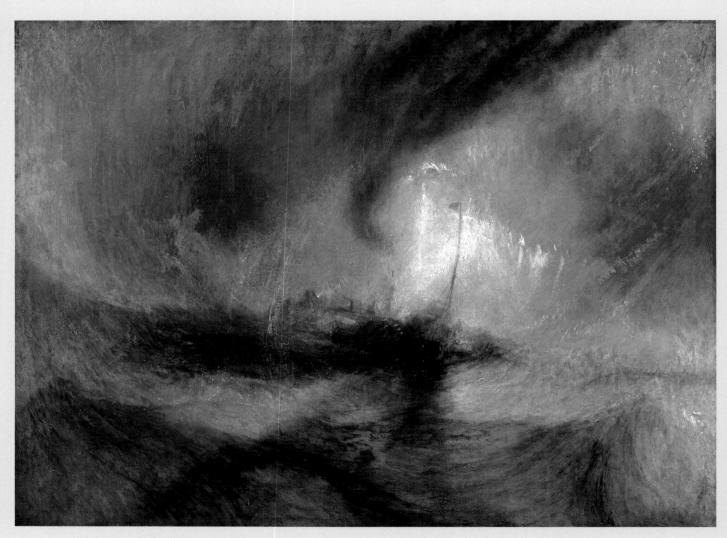

Joseph Mallord William Turner. **Snow Storm—Steam-Boat off a Harbour's Mouth.**
1842. Oil on canvas

TURNER TO HIS CRITIC
BY GRACE NICHOLS

(who dismissed his Snow Storm—Steam-Boat off a Harbour's
Mouth, *1842, as "soapsuds and whitewash"). Turner was said to
have tied himself to the mast of a ship to experience a snowstorm.*

Soapsuds and whitewash, Critic?
Man, don't make me livid.
I was tied in a snowstorm
To the mast of a ship.
Do you have the foggiest of it?
Do you know what it is to be buffeted?

The buzzard of a blizzard
And the waves churning over me
The wildness of the whirlwind
The horses foaming at my feet

Why, even the sea can see through
Her storm-spectacles
That this work is a masterpiece.
Soapsuds and whitewash indeed!
If I had my way, you, Sir, would be
Soap-sudded to the bottom of the sea.

Ritratto di Giovane
Translated into Italian by Rina Ferrarelli

Eccomi qua,
pare che dica
il giovane fiorentino
guardandomi
con serietà
e franchezza,
un adolescente
che si fermò
a mezzo passo,
mezz' alito,
appena il tempo
di fare
il ritratto, nemmeno
un minuto, nemmeno
il tempo di disporre
l'espressione
del viso, del corpo
in linee di riposo,
ansioso d'andare,
arrivare
dove stava andando.

Portrait of a Young Man
By Rina Ferrarelli

Èccomi, here I am,
the young Florentine
seems to say
looking earnestly
and directly at me,
a teenage boy
who stopped
in mid-stride,
mid-breath,
just long enough
to have his picture
painted, less
than a minute,
not long enough
to settle his expression
his body
into lines of rest,
eager to go, arrive
where he was going.

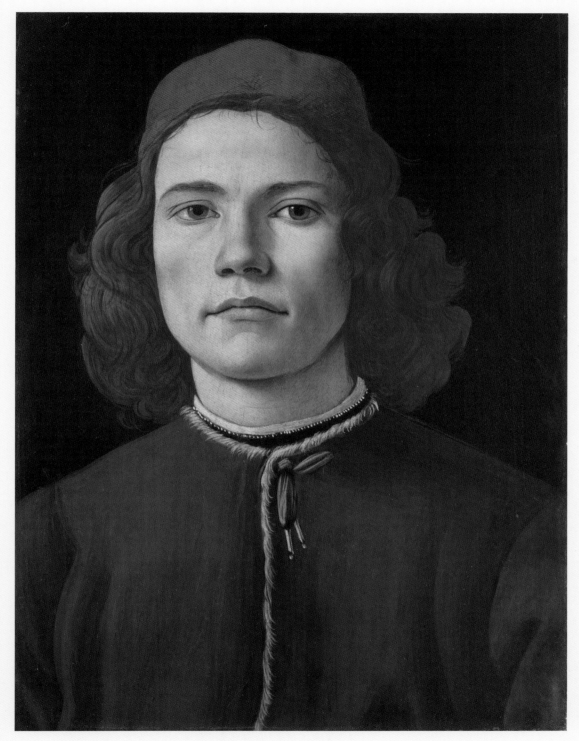

Sandro Botticelli. **Portrait of a Young Man**. c. 1480–85. Tempera on panel

To Prince Edward Island
By Carol Malyon

ask her what she watches
if she answers she will lie

she will say she looks at
earth or sea or sky
& needs binoculars
to see clearly

she hides behind them
the way astronauts deep sea divers
radiation workers all travelers
in alien atmospheres
are awkward inside the costumes
they wear for safety

this woman travels on this ferry
the way she travels everywhere

a man sits behind her
she knows this

Alex Colville. To Prince Edward Island.
1965. Acrylic emulsion on masonite

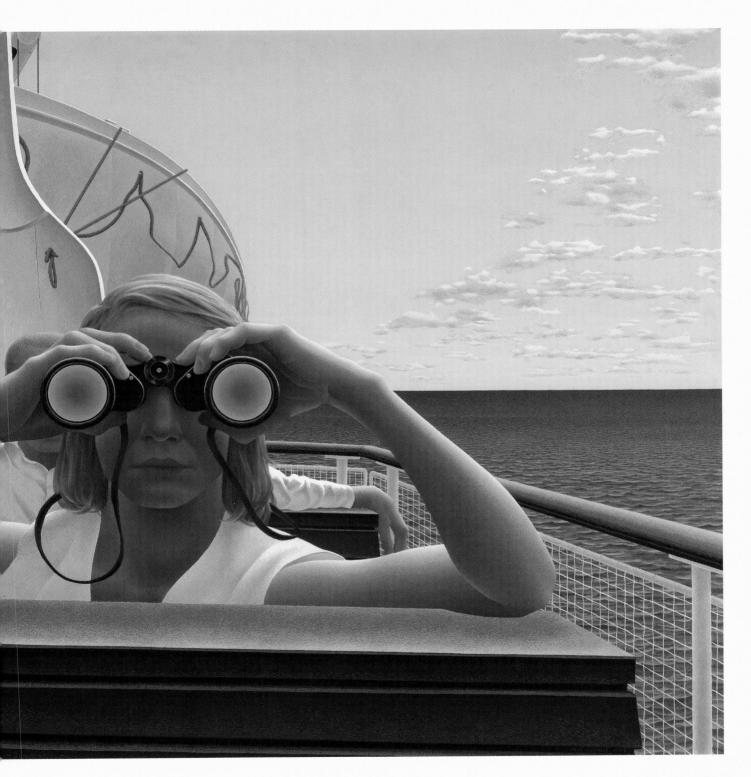

미륵반가좌사유상의 오늘

BY KO UN

이득히
56억7천만년 뒤에 오실
마이트레야를
아득히
56억7천만년 앞으로 불러낸
꿈

마이트레야 반가좌사유상의 달밤

어찌 이다지 고요하냐
어찌 이다지 꽃 지도록 고요하냐
폭풍이여 오라
이 고요 모조리 가져가거라

그대의 사유는 너무 요염하다

어찌 이다지 어여쁘냐
암흑이여 오라
이 숨막히는 어여쁨 다 지워버려라

아득히 56억7천만년의 오늘

MAITREYA, FUTURE BUDDHA, TODAY
TRANSLATED FROM THE KOREAN BY
BROTHER ANTHONY AND GARY G. GACH

Dream
bringing Maitreya—due to come
far in the future,
5,670,000,000 years later—
here, now,
5,670,000,000 years early.

Moonlit night with Maitreya sitting in meditation

How can you be so still?
Your stillness makes flowers fall.
Arise, storms,
blow away every last trace of that stillness.

Your meditation is way too sensual.

How can you be so beautiful?
Arise, darkness,
blot out this breathtaking beauty.

Today, 5,670,000,000 years in the far-off future,
my life is a sea of surging waves.

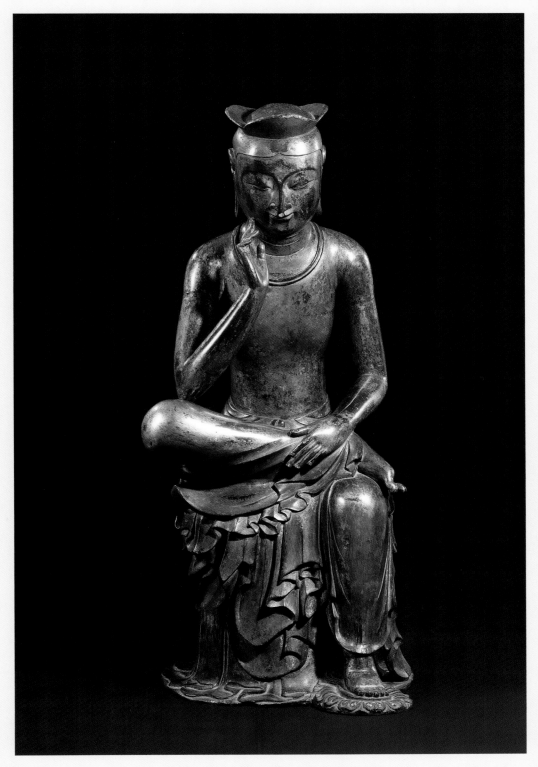

Banga Sayusang (Future Buddha).
Three Kingdoms Period, early seventh century. Gilt bronze

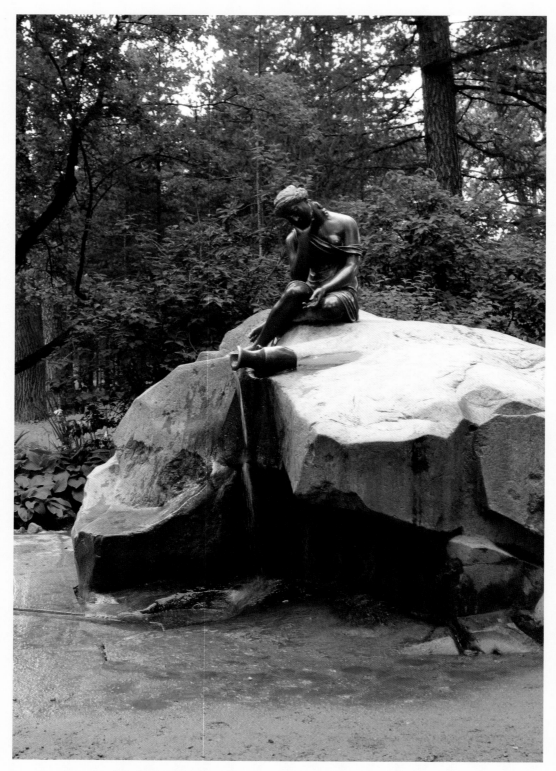

Pavel Sokolov. **The Girl with the Pitcher**. 1810. Bronze

Царскосельская статуя
BY ALEXANDER PUSHKIN

Урну с водой уронив, об утес ее дева разбила.
　　Дева печально сидит, праздный держа черепок.
Чудо! не сякнет вода, изливаясь из урны разбитой;
　　Дева, над вечной струей, вечно печальна сидит.

A Statue at Tsarskoye Selo
TRANSLATED FROM THE RUSSIAN
BY CARLETON COPELAND

How did she let the jug slip? Now, alas, on the rock it lies broken.
　　Sorely the maiden laments, futilely lifting a shard.
Wonder of wonders! The water that spills from the jug never dwindles.
　　By a perpetual source, ever lamenting she sits.

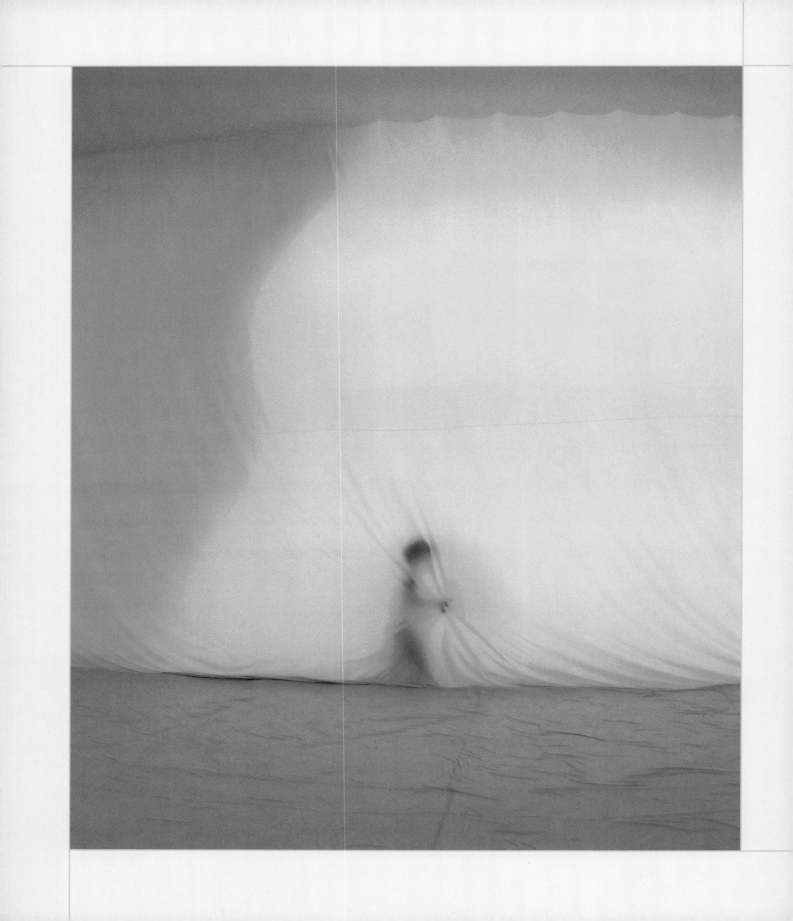

Impressions

貓 的 天 堂
BY LO CH'ING

一場老鼠的盛筵
出現在貓的夢中

在那香氣四溢的夢中
老鼠們都昏睡了過去

夢見了
一隻貓

以吃夢
維生

CAT HEAVEN
TRANSLATED FROM THE CHINESE
BY JOSEPH R. ALLEN

Out of the cat's dream
floats a lavish mouse banquet

As mice sleep deep
in that aroma-soaked dream

Dreaming of
a cat

Eating dreams
for sustenance

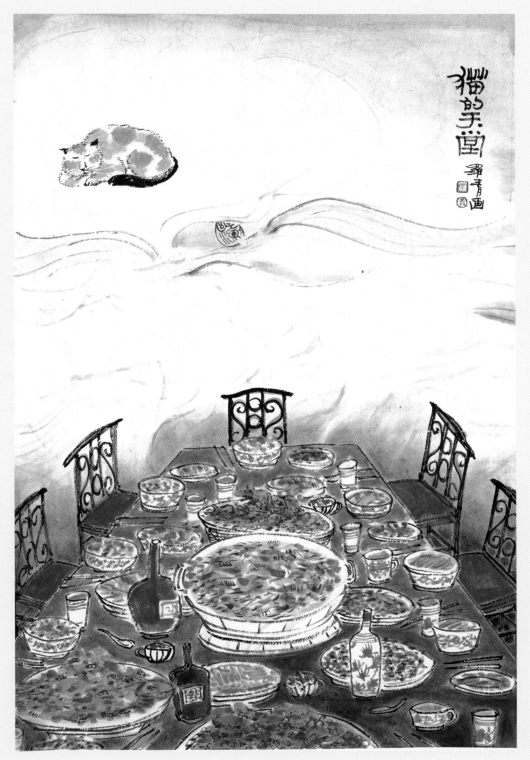

Lo Ch'ing. Cat's Heaven. 1986. Hanging scroll, ink on paper

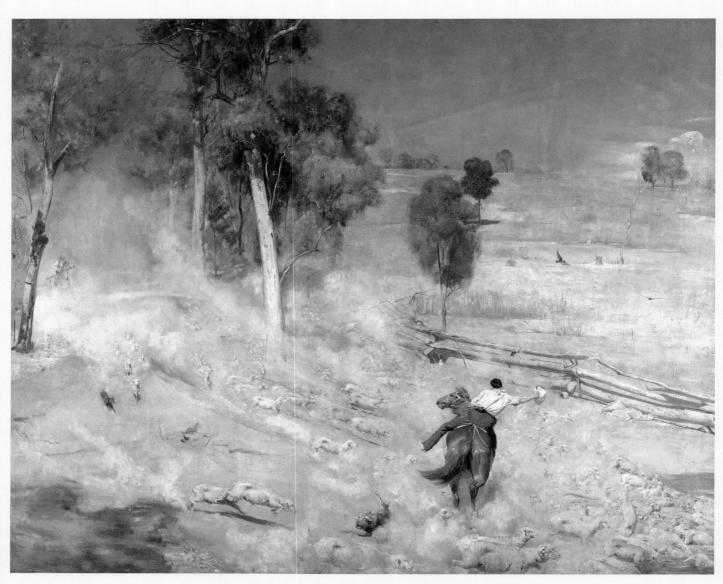

Tom Roberts. **A break away!** 1891. Oil on canvas

It's a dog-dust day
BY JANEEN BRIAN

It's a dog-dust day.
Sky clamps the brown land in blue heat.
Hawks swing lazy circles
near an archway of tall eucalypts.

It's a dog-dust day
on the sheep-filled track;
woolly animals hemmed in by crouching dogs
sloe-eyed, sharp-eared, firecrackers when need be.

It's a dog-dust day.
Stockmen shuffle the mob along
with cracks of cries and whistles that split the air.
Then the scent of water, a tumble,

and the sudden leap of a dream-startled sheep
and the mob explodes, scatters, bounds over
fences where none exist!

A break away!

A confusion of bleating and bustling that chokes the track
and a stockman swerves his horse and swipes his hat,
on that shattered, scattered
dog-dust day.

CAPE COD EVENING
BY ERNEST FARRÉS

N'hi ha moltes més, de ganes de fer el mandra,
quan les clarors vesprals desmagnetitzen
els camins i la brossa i el bosquet,
donen al dia un to grisenc i esporguen
arestes i margallons.
 Però cal,
que passi això, perquè tots, el marit,
la muller, el gos, s'estiguin en silenci
sense la pressió dels protocols,
sentin el vent xiulant entre les branques
o flairin una olor de figues.
 Oh
com vagaregen els seus ulls (mig clucs,
en caure la tarda) pels regalims
de les soques, la brosta, les arrels,
les taques d'ombra, els formiguers, les pedres
i els llangardaixos dels camps del voltant.

Qui més qui menys fa els comptes de les ànimes
d'éssers pròxims que han pres, potser, la forma
de gotes tornassolades de pluja.

CAPE COD EVENING
TRANSLATED FROM THE CATALAN
BY LAWRENCE VENUTI

You really feel like lazing around
when the twilight takes the glamour off
the paths, the underbrush, and the woods,
giving the day a grayish tint, pruning
ears of corn and palms.
 This has to
happen for all of them—husband,
wife, dog—to fall silent
with no need for pleasantries,
listening to the wind whistle in the branches
or picking up the scent of figs.
 And how
their eyes (half-closed, as night falls)
wander over the trickle
down the trunks, buds, roots,
the smudges of shadow, ant hills, stones
and lizards in the fields all around.

Everyone more or less counts the souls
of the dearly departed who take the form, perhaps,
of iridescent drops of rain.

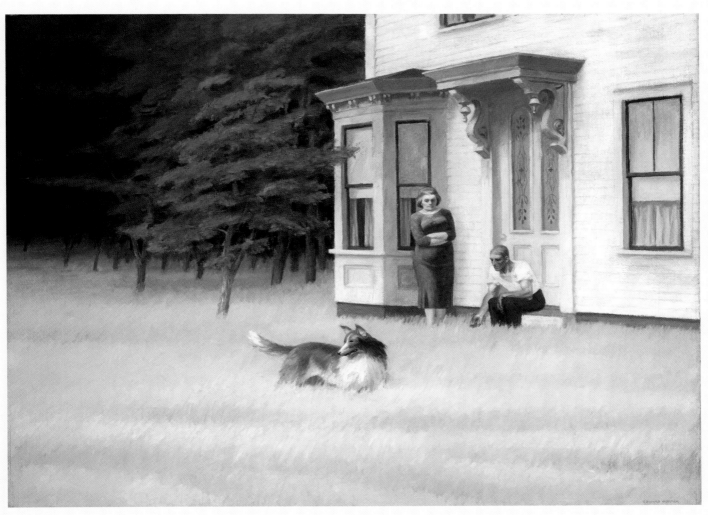

Edward Hopper. Cape Cod Evening. 1939. Oil on canvas

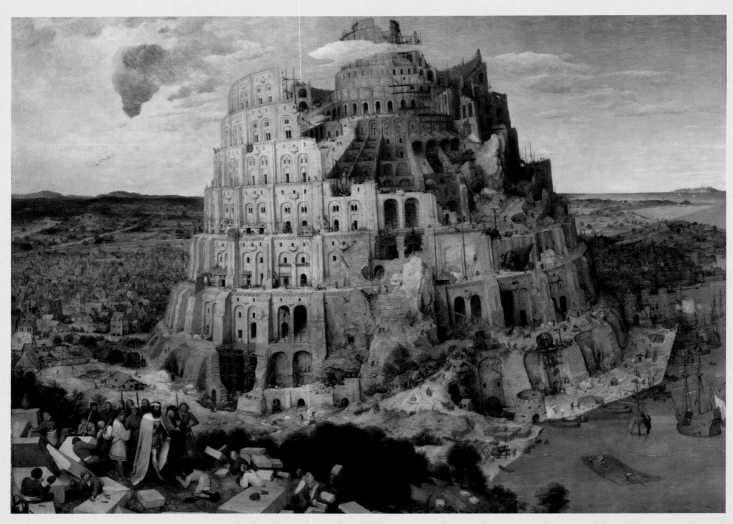

Pieter Brueghel the Elder. The Tower of Babel. 1563. Oil on oakwood

Babel
BY CRISTINA PERI ROSSI

Silenciosa
 enigmática
la gran torre
se eleva
al infinito
Única construcción
en la ciudad desierta
inanimada
Babel silenciosa
 Luego de la bomba.

Babel
TRANSLATED FROM THE SPANISH
BY SEAN HIGGINS

Silenced
The Great Tower
a jenga survivor
Rises up
to infinity
Sole construction
In the desert city
the deserted city
lifeless
Babel silenced
 Since the bombing.

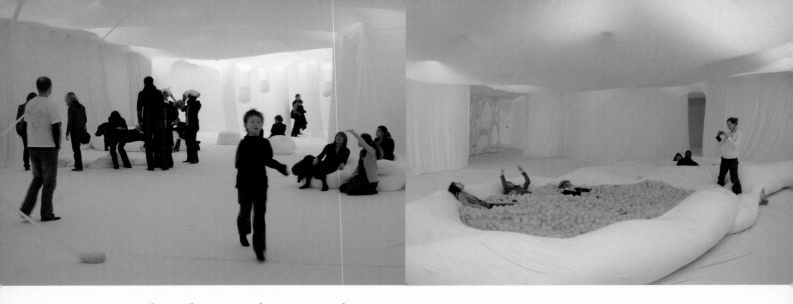

a catastrophe theory (excerpt)
by franck leibovici
translated from the french by tatiana grigorenko

(in this small sphere), nothing *ostensibly* happens

like accidents of form
defined in a given space

the word "catastrophe"

something
h a p p e n s

a connection between certain local
phenomena and their environment

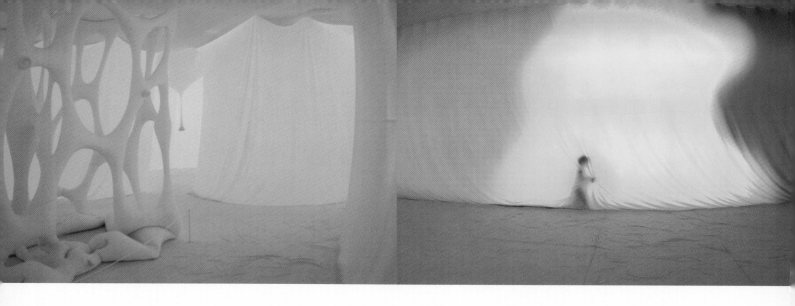

a bit of magic

a morphological process in a substrate space

of the movement of heavy bodies

an *epigenetic landscape*

from that moment on, i lost a bit of interest in mathematics

simulating the conditions of the exterior world

(the nervous system)

Ernesto Neto. The Malmö Experience. 2006. Mixed media

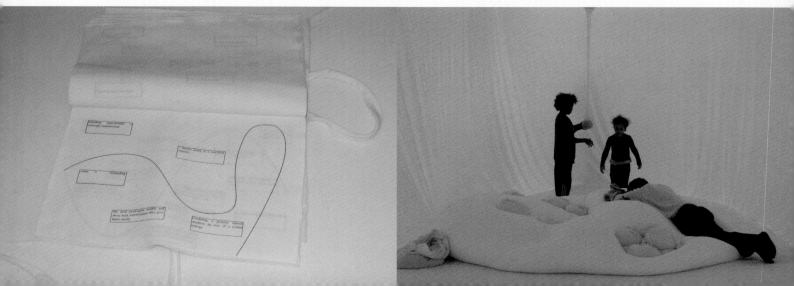

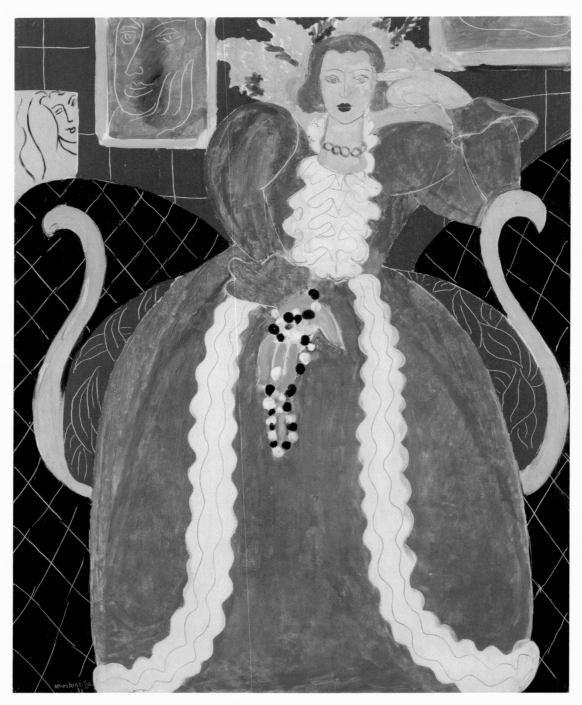

Henri Matisse. Woman in Blue. 1937. Oil on canvas

LA GRANDE ROBE BLEUE ET MIMOSA
BY JAMES SACRÉ

On entend souvent des noms de couleur dans les titres
Quand on regarde le tableau c'est comme
Si la couleur le dessinait : mieux
Que ce que le tableau figure, un canapé lyre
Qui est de la musique en rouge
Autour d'une robe en bleu. On sait pas
Comment s'en aller dans la profondeur : tout
Est donné là-devant ça
Te déborde dans le coeur (comme des noms de couleurs
Débordent dans les titres).

WOMAN IN BLUE
TRANSLATED FROM THE FRENCH BY DAVID BALL

Often you hear names of colors in the titles
When you look at the painting it's as
If the color were drawing it: better
Than what is shown in the painting, a sofa-lyre
Red music
Around a blue dress. You can't
Go out into the depths: everything
Is given right here up front it
Spills over into your heart (the way the names of colors
Spill over into the titles).

西元直子
BY NAOKO NISHIMOTO

風やんで、やぐるま草
まぶた閉じ
ねむるよる
うすあおの
螺旋のゆめ
鳥もむしも
鳥もむしも

ON DAWN
TRANSLATED FROM THE JAPANESE
BY SAWAKO NAKAYASU

wind lulls, cornflower
eyelids close
asleep at night
a faint blue
spiral dream with
birds & insects
birds & insects

Ei-Kyu. Dawn. 1957. Oil on canvas

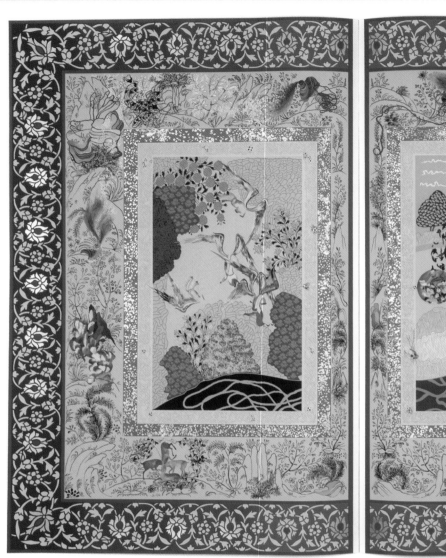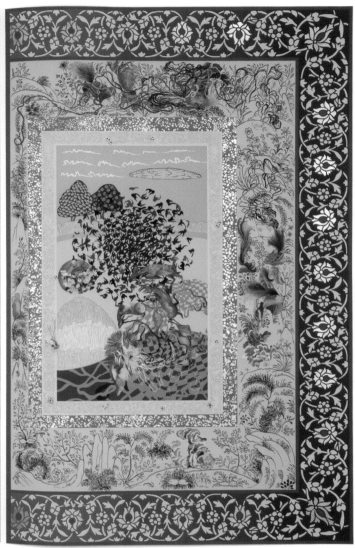

Shahzia Sikander. The Illustrated Page Series.
2005–06. Gouache, handpainting, gold leaf, silk-screened pigment

THE VISION
BY NIMAH ISMAIL NAWWAB

Mythical and real interweave
fantastical figures
Spirited unicorns, delicate deer,
flying fleeing flocks, fierce falcons
Nature unbound
an overflowing vista
 to hold close.

The healing, natural world
pink clouds, green hill tops,
 beckon.
As hidden, fragmented images
 surface.

The mysteries of life, of change
 mysteries of past and present
 unravel.
 Strain and buck
 to be released.

Yet the spirits,
 Life,
 dance full out,
 evolve,
 transform into continuous miracles.

Biographies of the Poets and Translators

Joseph R. Allen is a professor of Chinese literature at the University of Minnesota, Twin Cities. His literary work focuses on Chinese poetry and poetics, from an edition of the *Book of Songs* (c. 600 BCE) to contemporary poetry. His current research also includes a study of classical Chinese poetry in modern cultures, and a study of Taipei City.

María Teresa Andruetto was born in 1954 in Arroyo Cabral, in the Argentine province of Córdoba, where she still lives today. After studying literature at the Universidad Nacional de Córdoba, she specialized in children's and young adult literature. She has published scores of short stories, novels, poems, and plays for all ages. Her awards include one for the children's book *El anillo encantado* and *Huellas en la arena*.

Brother Anthony has lived in Korea since 1980 and was naturalized with the name An Sonjae. A member of the Community of Taizé, he is a professor of English literature at Sogang University, Seoul. His translations of modern Korean poetry and fiction now exceed twenty volumes.

Roy "Chicky" Arad, born in 1976 in Beer Sheva, Israel, creates poetry, music, art, and films. He has published three books and released five albums of music and poetry in Israel, the United States, France, and Holland. His poetry, Arad says, "is political but optimistic. 'The Corpse' is slightly different."

David Ball's *Darkness Moves: An Henri Michaux Anthology 1927–1984* won the MLA's Scaglione Prize for Outstanding Literary Translation in 1996. His translations of James Sacré have appeared in a dozen books, anthologies, and journals, including *Poetry*; his version of Jarry's *Ubu* will appear shortly in the *Norton Anthology of World Theater*. His own poetry has been published in journals and six chapbooks. He is a professor emeritus of French and comparative literature at Smith College.

Carmen T. Bernier-Grand was born in Puerto Rico. She has a master's degree in mathematics from the University of Puerto Rico Mayaguez Campus. She left Puerto Rico to study advanced math at the University of Connecticut. She is the author of five books for children and young adults. Her book *Cesar: !Si, se puede! Yes, We Can!* is published in both Spanish and English. *Frida: ¡Viva la vida! Long Live Life!* will be out in 2007, and *Diego: Bigger Than Life* in 2008. She and her husband live in Portland, Oregon, with their bilingual dog.

Janeen Brian, who lives in seaside Glenelg in South Australia, writes poetry, fiction, and nonfiction. She has published sixty-two books and has received many awards, including six Notable Awards and three Children's Book Council of Australia Honour Awards for *Hoosh! Camels in Australia*, *Where Does Thursday Go?*, and *Pilawuk—When I Was Young*. Her most recent novel is *Cross-Currents*. She has worked in Australia as a teacher/librarian and an actor/writer in a children's theater company.

Charles Cantalupo, a poet, scholar, critic, playwright, and teacher, is the author of a book of poems, *Light the Lights*, and *Who Needs a Story? Contemporary Eritrean Poetry in Tigre, Tigrinya and Arabic*. He has also published books on Thomas Hobbes and Ngugi wa Thiong'o, and he has written and directed the documentary *Against All Odds: African Languages and Literatures into the 21st Century*. He is a professor of English, comparative literature, and African studies at Penn State University.

Gerald Chapple lives in Dundas, Ontario. He received a Translation Award from the Austrian government (1996). His translations of Günter Kunert's work have appeared in over twenty literary magazines and are being collected for a book, *A Stranger at Home: Selected Poems 1979–2004*.

Lo Ch'ing was born in mainland China in 1948 and moved to Taiwan when he was three years old. He is a

painter as well as a poet; his interest in Ch'an (Zen) Buddhism and in Taoism is evident in his works. He learned traditional Chinese painting as a child and continues to work in this medium, in addition to his teaching and writing career. A Fulbright scholar, he has lectured and exhibited his work throughout the United States and Europe.

Martha Collins is the author, most recently, of *Blue Front*, a book-length poem based on a lynching her father witnessed when he was five years old in Cairo, Illinois, published in May 2006. She has also published four collections of poems, two books of co-translations from the Vietnamese, and a recent chapbook of poems. Collins's awards include three Pushcart Prizes, the Alice Fay Di Castagnola Award, and a Lannan residency grant. A selection of poems from *Blue Front* won the Laurence Goldstein Poetry Prize in 2005. Collins teaches at Oberlin College, where she is the Pauline Delaney Professor of Creative Writing.

Carleton Copeland, a native of Detroit, fell in love with Russian at the University of Michigan. Pursuing his passion to Leningrad in the 1980s, he spent several delirious winters living in ramshackle dormitories, muttering verb conjugations and wandering the streets of the crumbling imperial capital. The charm has never worn off. He now works as a translator for Ernst & Young in Moscow and spends evenings and weekends obsessively translating Russian poetry.

Thuy Dinh is a writer and attorney who lives in Washington, D.C. She graduated cum laude with degrees in English and in French literature from the University of Virginia in 1984, and received her law degree (JD) from the University of Virginia School of Law in 1987. Her essays and reviews have appeared in *Rain Taxi Review of Books*, *Hop Luu Magazine*, *Amerasia Journal*, and *Twenty Years of Vietnamese American Experience*. She co-translated with Martha Collins *Green Rice: Selected Poems of Lam Thi My Da*.

Yusuf Eradam, born in 1954 in Central Anatolia, Turkey, is a poet, short-story writer, translator, songwriter, and photographer. He graduated from **Darüşşafaka**, a boarding school for orphans in Istanbul, and the Department of English Language and Literature of Hacettepe University, Ankara, where he received his MA (1979) and PhD (1986). He has written ten books and published numerous translations, including the work of Sylvia Plath. He lives in Istanbul, Turkey.

Ernest Farrés is the author of three volumes of poems: *Hit or Miss*, *Mosquitoes*, and *Edward Hopper*, which won the Englantina d'Or dels Jocs Florals. He has also edited *21 Poets of the 21st Century: An Anthology of Young Catalan Poets*. A journalist for the newspaper *La vanguardia*, he lives in Barcelona.

Rina Ferrarelli, who moved to the United States from Italy at sixteen, is a poet and translator of modern Italian poetry. She has published a book and a chapbook of original poetry, *Home Is a Foreign Country* and *Dreamsearch*, and two books of translations, *I Saw the Muses* and *Winter Fragments*. She received a National Endowment for the Arts grant, and the Italo Calvino Prize from the Columbia University Translation Center.

Renée Ferrer, born in Paraguay, is a poet and a writer of short stories and novels, as well as a doctor in history from the National University of Asunción. She has published two collections of poetry, *Poesía completa hasta el año* and *Las cruces del olvido*. Her first novel, *Los nudos del silencio*, has been translated into French and Italian. She also wrote *Vagos sin tierra*, a historical novel about Paraguay (in the eighteenth century), as well as several collections of short stories. She also has written poetry and stories for children. Her work has received national and international prizes.

Gary G. Gach is a poet, translator, and writer living in San Francisco. He is the author of *The Complete Idiot's Guide to Understanding Buddhism* and the editor of the Buddhist poetry anthology *What Book!?* for Parallax Press. His translation of *Flowers of a Moment*, by Ko Un, received the 2007 Northern California Book Award for Translation.

Roger Greenwald attended the City College of New York, the St. Marks in the Bowerie Poetry Project workshop, New York University, and the University of Toronto. He has won the CBC Literary Award twice (for poetry and travel literature). His books include *Connecting Flight*; *Through Naked Branches: Selected Poems of Tarjei Vesaas*, a finalist for the PEN Award for Poetry in Translation; and *North in the World: Selected Poems of Rolf Jacobsen*, winner of the Lewis Galantière Award (American Translators Association).

Tatiana Grigorenko, a photographer from New York, lives in Paris.

Eran Hadas is an English translator who lives in Israel.

Gunnar Harding, born in 1940, is one of Sweden's foremost poets. He started as a jazz musician, studied painting in Stockholm, and made his literary debut in 1967. He has published—in addition to translations and nonfiction—sixteen volumes of poetry. In 1992 he was awarded the Bellman Prize by the Swedish Academy. In 1995 he was awarded the *Svenska Dagbladets* Literature Prize in recognition of his important role in Sweden's literary life since the 1960s, and in 2001 he won the prestigious Övralid Prize.

Sean Higgins, who was born in New York, is a teacher in the California public schools. He has had two novels published in translation: *When I Was a Boy Neruda Called Me Policarpo: A Memoir*, by Poli Délano,

and *Rattlesnake*, a translation of Arturo Arias's *Cascabel*. Currently working on translations of novels by Guatemalan writer Arturo Arias and Chilean writer Poli Délano, he is set to co-translate a recent anthology of Cristina Peri Rossi's poetry. The tower referred to in the poem "Babel," he says, "was in what is now Iraq. It is a reminder of what was and what remains and that bombs erase so much. Art—painting and poetry—serve to preserve what was and what remains, if only in artistic representation."

Wafaa S. Jdeed, born in Syria in 1970, is a poet and artist. She completed her art studies at the Adham Ismail Fine Arts Center, after graduating with a BA in economics from the University of Damascus. She is a member of the Syrian Order of Arts. Her work, using mostly silk and watercolors as media, has been featured in solo and group exhibitions since 1997 in Syria, Lebanon, and the United Arab Emirates. She currently lives and works in Dubai, UAE.

Assef al-Jundi is a native of Syria. His poems have appeared in anthologies and periodicals, such as *Chance of a Ghost*, *Poetic Voices Without Borders*, *The Spaces Between Our Footsteps: Poems and Paintings from the Middle East*, *Poets of the Lake I & II*, and the *San Antonio Express-News*. He lives in San Antonio, Texas. His poetry and artwork can be found online at: www.myspace.com/lahab

Ko Un, born in 1933 in Kunsan, North Cholla province, is Korea's foremost living writer. His first poems were published in 1958, while he was a Buddhist monk. A few years later he returned to the world. He became a leading spokesman in the struggle for democracy during the 1970s and 1980s. He has published more than 120 volumes of poems, essays, and fiction. In recent years, selections from his work have been translated into at least fourteen languages, including several volumes in English.

Ryszard Krynicki, one of the most prominent poets of postwar Poland, was born in 1943 in Sankt Valentin, Austria, where his parents had been deported to a Nazi labor camp. He made his debut in 1968 with the collection *Speed of Chase, Speed of Flight*. His most recent collection, *Magnetic Point*, was published in 1996. He has received many awards, among them the Polish Poets' Award, the Koscielski Foundation Award, and the Robert Graves-PEN Club Award. Since 1989 he has run the prestigious independent publishing house a5, which publishes both established and emerging Polish poets, as well as literary essays and poetry in translation.

Günter Kunert was born in Berlin in 1929. He was forced to leave East Berlin in 1979 and now lives north of Hamburg. He has written many poems inspired by works of art and has published thirty volumes of verse along with numerous prose works.

Lam thi My Da, born in 1949 in the south central part of Vietnam, spent the Vietnam War in Quang Binh province, near the scene of much heavy fighting. Author of five books of poetry in Vietnamese, she is widely recognized as one of Vietnam's major poets. While her poetry reflects the cost of the war, her poems are grounded in her intimate involvement with the landscape, flora, and fauna of her country, and also explore love, motherhood, women's issues, and the sometimes difficult movement into middle age. Her book of poetry *Green Rice* has been translated into English.

franck leibovici, born in 1975, lives and works in paris. he collaborated with brazilian artist ernesto neto on his installation piece, *the malmö experience*, in sweden. his poem, "a catastrophe theory" ("une théorie des catastrophes"), consisted of a set of seventy-seven sentences, each printed on pieces of fabric and placed in a big hole in the installation. viewers could pick out sentences and pass them back and forth to each other, "like fortune cookies in a Chinese restaurant," he says, "until each sentence gets a personal meaning." all the sentences referred to some aspect of neto's work. they were then gathered together again in a fabric book, attached to a bag made by neto.

Tracy K. Lewis is a poet, as well as a translator of Latin American literature. He is the coordinator of Spanish at the State University of New York in Oswego, and has his PhD from Brown University. His special passion is literature from Paraguay and literature in the Guarani language.

Carol Malyon, born in Toronto, Canada, worked in health research, then owned a bookstore (Beaches Book Shop), but now writes full time—novels, short stories, poetry and recently, fiction for young children. *Mixed-Up Grandmas*, *Lovers and Other Strangers*, and *If I Knew I'd Tell You* are among her more recent works. She has won numerous awards, including being shortlisted for the SmithBooks/Books in Canada First Novel Award, for *If I Knew I'd Tell You*; and shortlisted for the Commonwealth Writer's Prize for Best First Book of Fiction (Canada and Caribbean), for *The Edge of the World*.

Lorraine Marwood, a writer and performer of poetry for children and adults, resides in rural Victoria, Australia. She has published two books of poetry for young readers, *Redback Mansion* and *that downhill yelling*, with a verse novel forthcoming in 2008.

Luis Martínez de Merlo, born in Madrid in 1955, is a high school teacher, as well as a poet and photographer. As a poet he has published two collections for young readers, *Oro parece* and *Ahora digo Diego*, as well as numerous volumes for adults, including *Orphenica lyra* (Poesia Alcalá prize), *Silva de sirenas*, *Alma del tiempo* (finalist, El Bardo prize), and *De algunas otras veces* (Puente Cultural prize). He has also published a short novel, *Un hombre anticuado*, and a collection of stories, *Rosa palida*.

Pat Mora, born in El Paso in 1942, is an award-winning author of over thirty children's books, as well as many books for adults. A former consultant, museum director, university administrator, and teacher, she has received the Hispanic Cultural Center Literary Award and a Poetry Fellowship from the NEA. Recent books for young readers include *¡Marimba! Animals A–Z*; *Dona Flor: A Tall Tale About a Giant Woman with a Great Big Heart*, which received a Golden Kite Award from the Society of Children's Book Writers and Illustrators; and a book of haiku, *Yum! ¡Mmm! Que rico!* Sharing what she calls "bookjoy," she founded the family literacy initiative Children's Day/Book Day ("Dia"), now housed at the American Library Association. She lives in Sante Fe, New Mexico.

Sawako Nakayasu was born in Japan and has lived most of her life in the United States. Her books include *Nothing fictional but the accuracy or arrangement (she*, *So we have been given time Or*, and *Hurry Home Honey*. Her translations from the Japanese include *Four from Japan*, featuring four contemporary poets, and *For the Fighting Spirit of the Walnut*, by Takashi Hiraide. She is the recipient of a 2007 NEA Literary Translation Fellowship and a 2006 PEN Translation Fund Grant.

Her own writing has been translated into Japanese, Swedish, Arabic, and Vietnamese.

Nimah Ismail Nawwab is an English writer, photographer, Saudi Arab activist, lecturer, and internationally recognized poet. Her work and her book *The Unfurling* have been featured in *Newsweek International*, MSNBC, the Associated Press, and the *Washington Post*. She is currently working on two anthology projects revolving around women and youth. Her poems have been published in anthologies and translated from English into numerous languages, including Japanese, Arabic, Urdu, and Indonesian.

Ghirmai Negash is an assistant professor of English and African literature at Ohio University. He was the founder and formerly chair of the Department of Eritrean Languages and Literature at the University of Asmara, Eritrea.

Grace Nichols was born in Georgetown, Guyana, in 1950 and grew up in a small country village on the Guyanese coast. She moved to the city with her family when she was eight, an experience central to her first novel, *Whole of a Morning Sky*. Her first poetry collection, *I Is a Long-Memoried Woman*, won the Commonwealth Poetry Prize, and a subsequent film adaptation of the book was awarded a gold medal at the International Film and Television Festival of New York. She also writes books for children, including *Come*

on into *My Tropical Garden*, *Give Yourself a Hug*, *Everybody Got a Gift*, and *Paint Me a Poem*, winner of the Children's Poetry Bookshelf Best Single Author Collection. Her most recent poetry collection is *Startling the Flying Fish*. She has lived in England since 1977.

John Nieuwenhuizen, who is a translator from the Dutch, was born in the Netherlands and later emigrated to Australia, where he now makes his home in Melbourne. His translation of *The Baboon King*, by Anton Quintana, won the Mildred L. Batchelder Award in 1999. He was awarded the NSW Premier's Translation Prize and the PEN Medallion in 2007.

Naoko Nishimoto was born in 1956 in Kagoshima, Japan. In 1998 she published the book *Kotori* (Bird), in collaboration with the painter Yuji Akatsuka. *Kemono-ou* (Animal King), a collection of poetry, was published by Shoshi Yamada in 2002. In 2004, her work was featured in *Okaeri* (Welcome Home), a collective exhibition of poetry at Pepper's Loft Gallery in Tokyo, along with that of seven other poets.

Cristina Peri Rossi, born in 1941, is an Uruguayan novelist, poet, and author of short stories. Considered a leading light of the post-1960s period of the Latin American novel, she has written more than thirty-seven works. A Guggenheim Fellow, she is the recipient of what is equivilant to the Pulitzer Prize in Spain for her last book of poetry,

Estragias del deseo. She was born in Montevideo, Uruguay, and left the country in 1972, moving to Spain, where she became a citizen in 1975. She lives in Barcelona.

Anne Provoost, born in Poperinge, Belgium, in 1964, studied literature at the University of Louvain. She is the author of five novels. Her books have been translated into fourteen languages and received major literary prizes. Her latest novel was longlisted for the International IMPAC Dublin Literary Award. Once a year, she writes a letter to Hans Christian Andersen answering one of his stories. She is a member of the Belgian Royal Academy of Dutch Language and Literature. She lives with her husband and three children in Antwerp.

Alexander Pushkin (1799–1837), born in Moscow into a noble Russian family, became Russia's foremost poet, lover, genius, victim, and cultural hero. His poetry caused such a stir that Tsar Nicholas I took time out from ruling the empire to censor his manuscripts, striking out verses that he felt were unsuitable. Pushkin married a renowned beauty and was mortally wounded at the age of thirty-seven in a duel defending her honor. He was and is, in the words of another poet, Russia's "first love."

Peter Robertson, the author and critic, was born in Glasgow in 1960 and lived in Norway, Spain, Argentina, and the Channel Islands. He was educated at the Universities

of Cambridge and London and worked for a number of United Nations organizations, including the International Monetary Fund and the World Bank. He has contributed to many publications, including the *Oregon Literary Review* and the *Salt River Review*, and is to be published in the *Literary Review* and *Turnrow*. He will be launching the *International Literary Quarterly* in Autumn 2007. He is a Fellow of the Royal Society of Arts.

James Sacré was born on a farm in the tiny village of Cougou in 1939. He is one of the leading poets in France, where he has won five prizes for poetry, including the Prix Apollinaire (1988); he was named Chevalier dans l'Ordre des Arts et des Lettres by the French government in 1987. He has published over forty books of poetry, and his poems have appeared in many French journals that publish poetry. He was a Chair Professor of French at Smith College.

Lawrence Schimel was born in New York in 1971 and now lives in Madrid, Spain. He is an author and anthologist, writing in both English and Spanish, who has published over eighty books in different genres. He collaborates frequently with the Spanish illustrator Sara Rojo Pérez to create children's books, such as *La aventura de Cecilia y el dragón* and *Misterio en el jardín*. Their picture book *No hay nada como el original* was selected by the International Youth Library in Munich for the White Ravens 2005. His poems have appeared in numerous anthologies.

Karma Ura, born in 1961 in Bhutan, received a degree in politics, philosophy, and economics from Oxford, and a degree in Economics from Edinburgh University. He has been a Bhutanese civil servant for the last seventeen years. He is currently the director of Bhutan's main research institute, the Center for Bhutan Studies, and the chief editor of the *Journal of Bhutan Studies*. He is a painter and the author of various articles and books. His main books are *Deities, Archer and Planners in the Era of Decentralisation*; *Festival and Faith in Nimalung*; *The Ballad of Pemi Tshewang Tashi: A Wind Borne Feather*; and *The Hero with a Thousand Eyes: A Historical Novel*.

Alissa Valles is a poet, editor, and translator from the Polish and the Russian. She has worked for the Institute of War Documentation in Amsterdam and the Jewish Historical Institute in Warsaw and now lives and works freelance in Warsaw and Berkeley, California. Her writing has appeared in *Poetry*, *Ploughshares*, the *Antioch Review*, the *TriQuarterly Review*, *Verse*, and elsewhere; her translations have appeared in the *Iowa Review*, *Modern Poetry in Translation*, *Jewish Quarterly*, *Harpers*, and the *New York Review of Books*. She has been the recipient of a Ruth Lilly Poetry Fellowship and the Bess Hokin Prize from *Poetry* magazine.

Lawrence Venuti is a translator as well as a translation theorist and historian. His recent translations include Antonia Pozzi's *Breath: Poems and Letters*, the anthology *Italy: A Traveler's Literary Companion*, and Massimo Carlotto's crime novel *Death's Dark Abyss*. He is the author of *The Translator's Invisibility* and *The Scandals of Translation* and the editor of *The Translation Studies Reader*. He is a professor of English at Temple University.

Nanezbah Nora Yazzie, born in 1954 in the Four Corners region of the Navajo Nation, is a sculptor and poet. Her work can be seen in the sculpture gallery of the Smithsonian Institute's newest National Museum of the American Indian in Washington, D.C. A life-long educator, she taught for the Native American Studies and English Departments at the University of New Mexico. As a writer and poet, she is published in numerous anthologies and is a contributing editor to a national native art magazine. She was cast in the Hallmark film *In from the Night*.

Ghirmai Yohannes is an actor, poet, and writer from Eritrea, in Africa. His work includes television shows, children's programs, videos, advertising, stand-up comedy, and theater. In Eritrea, he is popularly known as "San Diego," because as a fighter for Eritrea during its decades-long struggle for independence, he was usually seen wearing a T-shirt with the American city's name emblazoned across his chest.

Biographies of the Artists

Sandro Botticelli ("Little Barrel," 1445–1510) was an Italian painter of the Florentine school during the early Renaissance (Quattrocento), called the "golden age" of Italian painting. He developed a highly personal style characterized by an elegant execution and a strong emphasis on line.

Pieter Brueghel (c. 1525–69), usually known as Pieter Brueghel the Elder to distinguish him from his elder son, is generally considered the greatest Flemish painter of the sixteenth century. His detailed paintings, including his landscapes and scenes of peasant life, depict human weaknesses and follies.

Bùi Xuân Phái (1920–1988) was one of the most remarkable figures of Vietnamese modern art. A graduate of the École des Beaux Arts d'Indochine in Hanoi, he was familiar with the European masters yet he developed his own style. He is famous for his street scenes of Hanoi.

Lo Ch'ing see Biographies of the Poets and Translators

Alex Colville, born in 1920 in Toronto, Ontario, is a Canadian painter, often labeled a Magic Realist, for the strange, heightened atmosphere in his paintings. He studied art at Mount Allison University, N.B., and on graduating in 1942 joined the Canadian Army and served in Europe as a member of the War Art program.

He taught art and art history at Mount Allison University from 1946 to 1963 before devoting himself fulltime to his painting and printmaking. Colville's work has been exhibited all over the world.

Itzhak Danziger (1916–1977) is a sculptor and painter who immigrated from Berlin to Israel in 1923. His awards include the 1945–46 Dizengoff Prize and the 1968 Israel Prize for Sculpture. In the 1930s he created *Nimrod*, sculpted out of Nubian sandstone. This work, together with his sheep sculptures, became a unique expression of the local landscape, and a part of Israeli cultural heritage. In the early 1970s, Danziger initiated the rehabilitation of the Nesher Quarry (in the north of Israel, adjacent to Haifa) as an experiment in interdisciplinary work involving artists, ecologists, and scientists.

Ei-Kyu (1911–1960), born in Miyazaki City as Hideo Sugita, was one of the leaders of modern Japanese art. In 1925 he moved to Tokyo and began to study oil painting. He established his studio in Urawa in 1951, and from there continued his work with oil painting, photography, printing, and art criticism. The painting *Dawn* (1957) was selected as one of the great paintings of the twentieth century by the National Museum of Modern Art, Tokyo, where it is housed.

Edward Hopper (1882–1967) was an American painter best remembered

for his eerily realistic depictions of solitude in contemporary American life. His teacher Robert Henri motivated students to render realistic depictions of urban life. Henri's students, many of whom developed into important artists, became known as the Ashcan School of American art.

Wafaa S. Jdeed see Biographies of the Poets and Translators

Malola (Maria Gloria Echauri), born in 1954 in Coronel Oviedo, Paraguay, is an artist, teacher, and researcher in the arts. Since 1981 she has exhibited her work in Paraguay, Brazil, Argentina, and the United States. Her series *Cabellos* (Horses), paintings on porcelain, has won several awards and has been widely published in art magazines. She is a professor of painting at the National University of Asunción and directs the ArtexArte Experimental Workshop. Currently she is developing a painting project with children of the Ache Guayaki native community in Puerto Barra, Alto Parana, Paraguay.

Henri Matisse (1869–1954) was a French artist noted for his use of color and his fluid and original use of brushstroke. As a draughtsman, printmaker, and sculptor, but principally as a painter, Matisse is one of the best-known artists of the twentieth century.

Hans Memling (1435/40[?]–1494) is considered one of the most important "Flemish primitive" painters. Although he was born in Germany, he lived most of his life in Belgium. There is a museum in Bruges devoted to his body of work.

Edvard Munch (1863–1944) was a Norwegian Symbolist painter and printmaker, and an important forerunner of Expressionist art, in which emotions are stressed rather than realism. *The Scream* (1893; originally called *Despair*), Munch's best-known painting, is one of the pieces in a series titled *The Frieze of Life*, in which Munch explored the themes of life, love, fear, death, and melancholy.

Ernesto Neto, born in 1964 in Rio de Janeiro, Brazil, is considered one of the leaders of Brazil's contemporary art scene. His abstract installations are made of gossamer-thin, light, stretchable fabrics in nylon or cotton. Sometimes they are filled with scented spices and hang in tear-shaped forms like gigantic mushrooms or huge stockings. He also creates spatial labyrinths, which the visitor can enter and thereby experience and interact with. For Malmö Konsthall, Neto created *The Malmö Experience*, presented in a huge "organic labyrinth" of fabrics and shapes, which took up the entire exhibition space. He collaborated with the poet franck leibovici on this project.

Sidney Nolan (1917–1992), born in Melbourne, Australia, is Australia's most internationally known artist. A love of music and literature is evident in many of his works, both thematically and visually. He was fascinated with the Australian landscape and used the legend of the late-nineteenth-century bushranger Ned Kelly to explore the landscape in a new way.

Pablo Picasso (1881–1973) was a Spanish painter and sculptor who lived and worked in France. One of the most recognized and prolific figures in twentieth-century art, he is best known as the cofounder, along with Georges Braque, of Cubism, a direction in modern art that dissected forms in nature into geometric shapes.

Diego Rivera (1886–1957) was one of Mexico's most important modern painters and muralists. Referring to *Pan American Unity*, Rivera said, "I believe in order to make an American art, a real American art, this will be necessary, this blending of the art of the Indian, the Mexican, the Eskimo, with the kind of urge which makes the machine . . ."

Tom Roberts (1856–1931) Born in Dorset, England, he grew up in Melbourne, Australia. His works are now the best loved of all Australian paintings. He was one of the first painters to recognize the special character of the Australian landscape. He started a school in Melbourne in 1885 based on the *en plein air* principles, or painting in the open air.

Dante Gabriel Rossetti (1828–1882) was an English poet, illustrator, painter, and translator. He was a founder of the Pre-Raphaelite Brotherhood, known for its romantic, decorative imagery.

Shahzia Sikander, born in 1969 in Lahore, Pakistan, is a painter living in New York City. She earned a BFA in 1992 from the National College of Arts in Lahore, Pakistan, and an MFA in 1995 at the Rhode Island School of Design in Providence, Rhode Island. She has had solo exhibitions at the Hirshhorn Museum and Sculpture Garden (1999/2000) and at the Renaissance Society at the University of Chicago (1998). Her work has been shown in many group exhibitions, including ones at the Whitney Museum (1999/2000 and 1999), the Ludwig Museum, Cologne, Germany (1999), and the Museum of Modern Art, New York (2006). She was awarded a "genius grant" for 2006 by the MacArthur Foundation.

Pavel Sokolov (1764–1835) was a Russian sculptor noted for his monumental artwork and decorative work in the Classical style. He served as Master of the Carving at the Admiralty in St. Petersburg.

Lawrence F. Sykes, born in 1931, is a retired professor of art. He designs book jackets and illustrates for poets and writers, including Frank Chipasula, Michael Harper, Ngugi wa Thiongo, and Charles Cantalupo. Sykes continues to create his art and to exhibit. In 2005 his work was

the subject of a retrospective show at Gallery Z in Providence, Rhode Island. In 2001, he had a one-man retrospective at the Newport Art Museum.

Joseph Mallord William Turner (1775–1851) was an English Romantic landscape painter and watercolorist whose style can be said to have laid the foundation for Impressionism.

Karma Ura see Biographies of the Poets and Translators

Diego Rodriguez Velázquez (1599–1660) was one of Spain's most celebrated painters, the leading artist in the court of King Philip IV. In addition to numerous renditions of scenes of historical and cultural significance, he created scores of portraits of the Spanish royal family, other notable European figures, and ordinary people.

Reha Yalnizcik, born in 1950, graduated from the State School of Applied Fine Arts (now a college of Marmara University) in Istanbul, Turkey, in 1975. He has won many awards for his book covers, posters, and illustrations. There have been over fifty-eight exhibitions of his work. In 1989 he hosted a TV program to teach children how to draw and paint. In 1992 he received the Contribution to Children's Paintings Award. He lives in Istanbul.

Nanezbah Nora Yazzie See Biographies of the Poets and Translators

Poetry Credits

Page 10: "Los Músicos Mexicanos" and the English translation "Mexican Musicians" © 2008 by Pat Mora. **Page 13**: "Màu Phô Phái" © 2005 by Lam thi My Da from *Green Rice*. English translation "The Color of Phai Street" by Martha Collins and Thuy Dinh. Curbstone Press, 2005. Reprinted with permission of Curbstone Press. Distributed by Consortium. **Page 14**: "Peras" © 2008 by María Teresa Andruetto. English translation "The Pears" © by Peter Robertson. **Page 16**: "Yaprak Elim Sende" and the English translation "Two Leaves in Snow" © 2008 by Yusuf Eradam. **Page 19**: "Galope" © 2008 by Renée Ferrer. English translation "Gallop" © 2008 by Tracy K. Lewis. **Page 20**: "Dubbelgångarna" © 2001 by Gunnar Harding from *Salongsstycken: Kring Dante Gabriel Rossetti: dikter*. Reprinted by permission from Gunnar Harding. Stockholm: Wahlström & Widstrand. English translation "The Doppelgangers" by Roger Greenwald. **Page 23**: "Quetzalcoatl" © 2008 by Carmen T. Bernier-Grand. **Page 24**: Excerpt from *The Ballad of Pemi Tshewang Tashi* © 1994 by Karma Ura. **Page 26–27**: "Tká Adí Díín" and "On the Path of Pollen" © 2008 by Nanezbah Nora Yazzie. **Page 30**: "Who Needs a Story?" © 2005 by Ghirmai Yohannes from *Who Needs a Story: Contemporary Eritrean Poetry in Tigrinya, Tigre and Arabic*. Edited and Translated by Charles Cantalupo and Ghirmai Negash. Asmara, Eritrea: Hdri Publishers. **Page 33**: "Ned Kelly" © 2008 by Lorraine Marwood. **Page 35**: "Retrato del Principe Baltasar Carlos de Caza" © 2008 by Luis Martínez de Merlo. English translation "Portrait of Prince Baltasar Carlos de Caza" © 2008 by Lawrence Schimel. **Page 36**: "Forest" © 2008 by Wafaa S. Jdeed. English translation © 2008 by Assef Al-Jundi. **Page 39**: "Der Schrei" © 2008 by Günter Kunert. English translation "The Scream" © 2008 by Gerald Chapple. **Page 40**: "The Corpse" © 2008 by Roy "Chicky" Arad. English translation © 2008 by Eran Hadas and Jan Greenberg. **Page 43**: "Bij Sibylle Sambetha Van Memling" © 2008 by Anne Provoost. English translation "Memling's Sibylle Sambetha" © 2008 by John Nieuwenhuizen. **Page 46**: "Muzeum Sztuk Pięknych w Budapeszcie" by Ryszard Krynicki. English translation "The Museum of Fine Arts in Budapest" © 2005 by Alissa Valles. First published in Words Without Borders (www.wordswithoutborders.org). By permission Words Without Borders, an online magazine. **Page 49**: "Turner to His Critic" © 2004 by Grace Nichols, reproduced with permission of Curtis Brown Group, Ltd. **Page 50**: "Ritratto di Giovane" and the English translation "Portrait of a Young Man" © 2008 by Rina Ferrarelli. **Page 52**: "To prince edward island" © 2002 by Carol Malyon from *Colville's People*. Canada: Mercury Press. **Page 54**: "미륵반가좌사유상의 오늘" © 2008 by Ko Un. English translation "Maitreya, Future Buddha, Today" © 2008 by Brother Anthony and Gary G. Gach. **Page 57**: "Царскосельская статуя" by Alexander Pushkin. English translation "A Statue at Tsarskoye Selo" © 2008 by Carleton Copeland. **Page 60**: "Cat Heaven" © 2008 by Lo Ch'ing. English translation © 2008 by Joseph R. Allen. **Page 63**: "It's a dog-dust day" © 2008 by Janeen Brian. **Page 64**: "Cape Cod Evening" © 1939 by Ernest Farrés from *Edward Hopper: Cinquenta poemes sobre la seva obra pictorica*. Reprinted with permission from Viena Edicions: Barcelona, Spain. English translation © 2008 by Lawrence Venuti. **Page 67**: "Babel" © 1999 by Cristina Peri Rossi from *Las musas inquietantes*. Barcelona, Spain: Random House/Mondadori S.A. English translation © 2008 by Sean Higgins. **Page 68**: "a catastrophe theory" (excerpt) © 2005 by franck leibovici (the malmö experience / Ernesto Neto 2005). Translated from the French by Tatiana Grigorenko. **Page 71**: "La grande robe bleue et mimosa" © 1998 by James Sacré from *La peinture du poème s'en va*. Tarabuste, France: St. Benoît-du-Sault. English translation © 2008 by David Ball. **Page 72**: "On Dawn" © 2008 by Naoko Nishimoto. English translation © 2008 by Sawako Nakayasu. **Page 75**: "The Vision" © 2008 by Nimah Ismail Nawwab.

Illustration Credits

Page 8: See credit for page 17. **Page 11**: *Mexican Musicians*. 1978. Ceramic musicians from the villages of Ocotlan de Morales and Coyotepec and from the Rio Balses area, Guerrero. Painted and carved wooden figures from Arrazola, near Oaxaca. Alexander Girard Installation: *Multiple Visions: A Common Bond 11-8*. The Museum of International Folk Art (DCA) Santa Fe, New Mexico. Photo by Blair Clark. **Page 12**: Bùi Xuân Phái. *Small Street*. 1985. Gouache on paper, 15 x 19 in. (38.1 x 48.26 cm). Private collection. **Page 15**: Pablo Picasso. *Dish of Pears*. 1936. Oil on canvas, 15 x 24 in. (3.8 x 6.1 cm). Tate Gallery Collection, London, England. © 2008 Estate of Pablo Picasso / Artists Rights Society (ARS), New York. Photograph: Tate, London 2007. **Page 17**: Reha Yalnizcik. *Two Leaves in Snow*. 1993. Acrylic on canvas, 19¾ x 27½ in. (50 x 70 cm). Private collection. **Page 18**: Malola (Maria Gloria Echauri). *Tornado*. 1996. Painting on porcelain disc, 11¹⁰⁄₁₆ in. (30 cm). From the *Breaking Paradigms* series. Courtesy the artist. **Page 21**: Dante Gabriel Rossetti. *How They Met Themselves*. c. 1850–60. Gouache on paper, 13³⁄₁₆ x 10¾ in. (33.9 x 27.3 cm). Fitzwilliam Museum, Cambridge, England. Courtesy the Bridgeman Art Library. **Page 22–23**: Diego Rivera. *Pan American Unity*. 1940. Mural on five panels. 6.74 x 22.5 m. All rights reserved. © City College of San Francisco, CA. **Page 25**: Karma Ura. *Wangdue Dzongan*. 1994. Painted on lime-coated cloth, 96 x 168 in. (243.8 x 426.7 cm). Courtesy the artist. **Page 26**: Nanezbah Nora Yazzie. *Corn Mother*. 2001. White clay embellished with corn husks and deer skin, 27 x 6 x 12 in. (68.6 x 15.2 x 30.5 cm). Courtesy the artist. **Page 28**: See credit for page 37. **Page 31**: Lawrence F. Sykes. *Massawa Moment*. 2005. Photograph on paper, 7½ x 5 in. (19 x 12.7 cm). Courtesy the artist. **Page 32**: Sidney Nolan. *Ned Kelly*. 1946. Enamel on composition board, 35¾ x 47¾ in. (90.8 x 121.5 cm). National Gallery of Australia. Gift of Sunday Reed 1977. **Page 34**: Diego Rodríguez Velázquez. *Portrait of Prince Balthasar Carlos de Caza*. 1635–36. Oil on canvas, 76 x 40½ in. (191 x 103 cm). Museo del Prado, Madrid, Spain. Photo credit: Erich Lessing / Art Resource, NY. **Page 37**: Wafaa S. Jdeed. *Forest*, from the exhibition Some Space for Dreamers in the Circle of Trees. 2004. Fateh El-Mudarres Gallery, Damascus, Syria. Silk colors on silk, 35¾ x 35¾ in. (90 x 90 cm). Collection Fidaa Jdeed. **Page 38**: Edvard Munch. *The Scream*. 1893. Tempera and pastels on cardboard, 35⁴⁄₅ x 28⁹⁄₁₀ in. (91 x 73.5 cm). National Gallery, Oslo, Norway. © 2008 The Munch Museum / The Munch-Ellingsen Group / Artists Rights Society (ARS), New York. Photo Credit: Erich Lessing / Art Resource, NY. **Page 41**: Itzhak Danziger. *Nimrod*. 1939. Nubian sandstone, 35²⁄₅ in. (90 cm). The Israel Museum, Jerusalem. Photo © The Israel Museum, Jerusalem. **Page 42**: Hans Memling. *Portrait of a Young Woman*. 1480. Oil on oak, 15 x 10½ in. (38 x 26.5 cm). Memling Museum, Sint-Janshospital, Bruges, Belgium. Photo Credit: Erich Lessing / Art Resource, NY. **Page 44**: See credit for page 48. **Page 47**: Outer Coffin of Henettawy. c. 1040–991 BCE. Thebes, Deir el Bahri. Plastered and painted wood, 79⁷⁄₈ in. (203 cm). The Metropolitan Museum of Art, New York. Rogers Fund, 1925 (25.3.182). Photograph © 1992 The Metropolitan Museum of Art. **Page 48**: Joseph Mallord William Turner. *Snow Storm—Steam-Boat off a Harbour's Mouth*. 1842. Oil on canvas, 36 x 48 in. (91.4 x 121.9 cm). Tate Gallery Collection, London, England. Photograph: Tate, London 2007. **Page 51**: Sandro Botticelli. *Portrait of a Young Man*. c. 1480–85. Tempera on panel, 14³⁄₄ x 11 in. (37.5 x 28.3 cm). Photograph: National Gallery, London. **Page 52–53**: Alex Colville. *To Prince Edward Island*. 1965. Acrylic emulsion on masonite, 24³⁄₈ x 36²⁄₅ in. (61.9 x 92.5 cm). Photograph: National Gallery of Canada. **Page 55**: *Banga Sayusang (Future Buddha)*. Early seventh century. Gilt bronze, 37 in. (93.5 cm). National Museum of Korea, Seoul. **Page 56**: Pavel Sokolov. *The Girl with the Pitcher*. 1801. Bronze. Catherine Park at Tsarskoye Selo, Russia. **Page 58**: See credit for page 68–69. **Page 61**: Lo Ch'ing. *Cat's Heaven*. 1986. Hanging scroll, ink on paper, 27¹⁄₂ x 18 in. (69.8 x 45.7 cm). Saint Louis Art Museum, Missouri. Gift of Lo Ch'ing in honor of Joseph R. and Lauren A. Allen. **Page 62**: Tom Roberts. *A break away!* 1891. Corowa, New South Wales, and Melbourne, Victoria. Oil on canvas, 50¹⁄₈ x 66¹⁄₁₆ in. (137.3 x 167.8 cm). Art Gallery of South Australia, Adelaide. Elder Bequest Fund 1899. **Page 65**: Edward Hopper. *Cape Cod Evening*. 1939. Oil on canvas, 30¹⁄₄ x 40¹⁄₂ in. (76.8 x 103 cm). National Gallery of Art, Washington. John Hay Whitney Collection. 1982.76.6. This photograph is not to be used for publication, commercial or advertising purposes without written permission from the National Gallery of Art, Photographic Services, Washington, D.C. 20565 U.S.A. **Page 66**: Pieter Brueghel the Elder. *The Tower of Babel*. 1563. Oil on oakwood, 44⁷⁄₈ x 61 in. (114 x 155 cm). Kunsthistorisches Museum, Vienna, Austria. Photo Credit: Erich Lessing / Art Resource, NY. **Page 68–69**: Ernesto Neto. *The Malmö Experience*. 2006. Installation view in Malmö Konsthall, Brazil. Lycra tulle, Polyamide stockings, cotton fabric, spices, sand, plastic balls, Styrofoam balls, polystyrene pellets, glass beads. Variable dimensions. **Page 70**: Henri Matisse. *Woman in Blue*. 1937. Oil on canvas, 36¹⁄₂ x 29 in. (92.7 x 73.7 cm). Philadelphia Museum of Art: Gift of Mrs. John Wintersteen, 1956. © 2008 Succession H. Matisse, Paris / Artists Rights Society (ARS), New York. **Page 73**: Ei-Kyu. *Dawn*. 1957. Oil on canvas, 31³⁄₅ x 25²⁄₅ in. (80.3 x 65.2 cm). Collection of the National Museum of Modern Art, Tokyo. **Page 74**: Shahzia Sikander. *The Illustrated Page Series*. 2005–06. One of three unique works on paper. Gouache, handpainting, gold leaf, silk-screened pigment, 117 x 75 in. framed (297.2 x 190.5 cm). In collaboration with The Fabric Workshop and Museum, Philadelphia. Courtesy the artist and Sikkema Jenkins and Co.

A map of the world showing where each poet, translator, and artist included in this book lives or lived. Use the biography section as a reference.

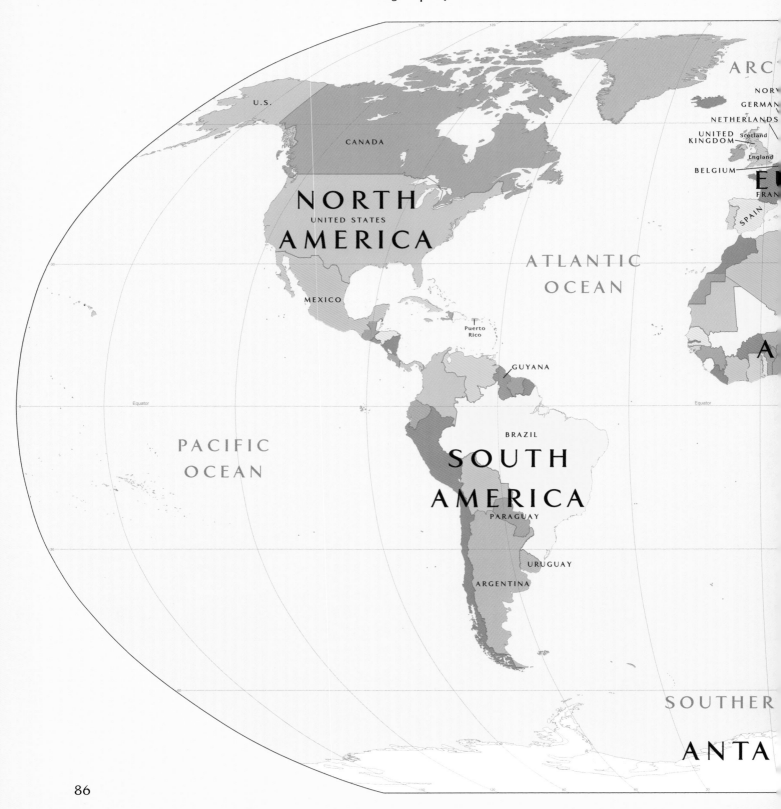

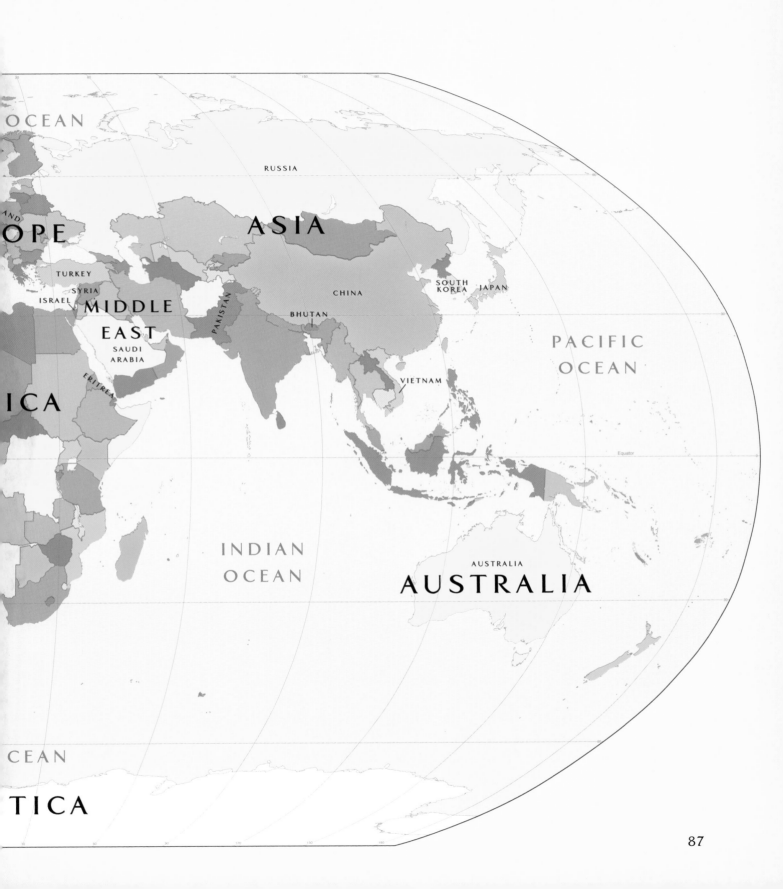

OCEAN

RUSSIA

ASIA

OPE

AND

TURKEY

SYRIA

ISRAEL

MIDDLE
EAST

SAUDI
ARABIA

ERITREA

ICA

PAKISTAN

CHINA

BHUTAN

SOUTH
KOREA

JAPAN

PACIFIC
OCEAN

VIETNAM

INDIAN
OCEAN

Equator

AUSTRALIA

AUSTRALIA

CEAN

TICA

Index